W9-DCD-265

# Hula Heaven

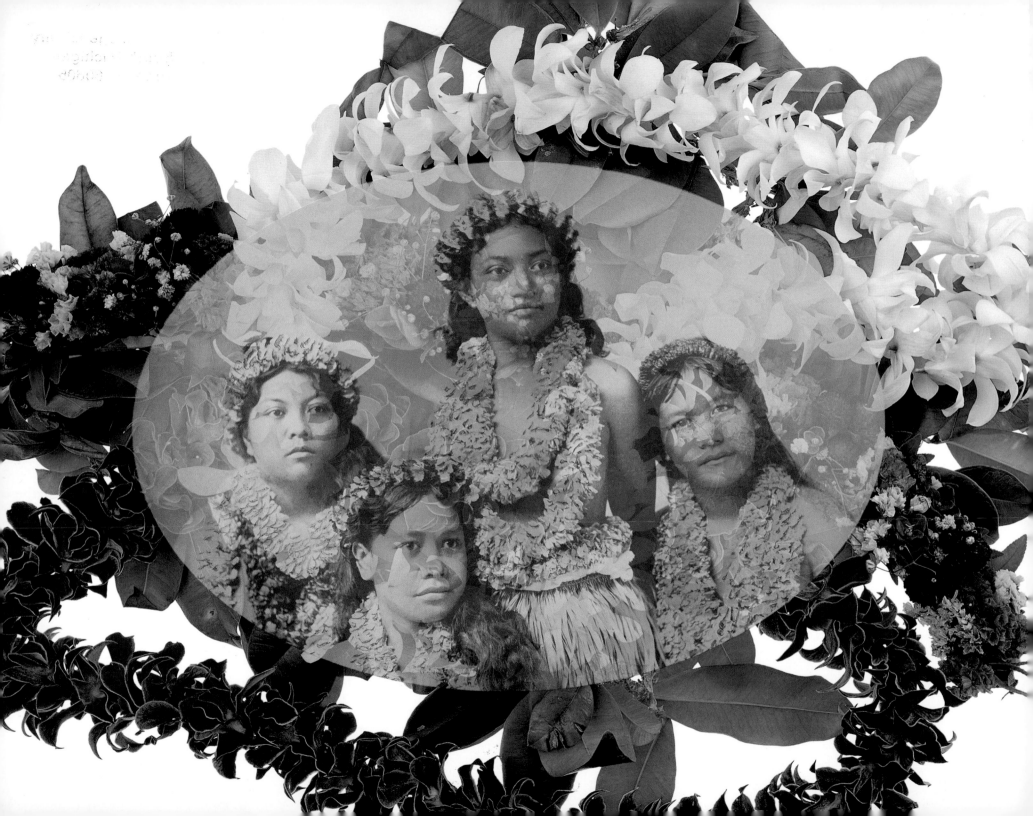

# Hula Heaven:

## The Queen's Album

Mark A. Blackburn

Schiffer Publishing Ltd

4880 Lower Valley Road, Atglen, PA 19310 USA

Author's Note: The absence of a glottal stop and the micron in Hawaiian names and words within the text is a deliberate omission and not due to an oversight. During the time period of the items covered in this book, correct pronunciations were universally known, making diacritical marks totally unnecessary and, therefore, not used.

Library of Congress Cataloging-in-Publication Data

Blackburn, Mark (Mark A.)
Hula heaven: the queen's album / by Mark A. Blackburn.
p. cm.
ISBN 0-7643-1333-9 (pbk.)
1. Liliuokalani, queen of Hawaii, 1838-1917--Juvenile literature. 2. Queens--Hawaii--Biography-Juvenile literature. 3. Hula (Dance)--History--Juvenile literature. 4. Hawaii--History--Juvenile literature. I. Title.
DU627.18.B58 2001
793.3'19969--dc21
00-013143

Edited by Nancy N. Schiffer
Designed by Bonnie M. Hensley
Cover design by Bruce M. Waters
Type set in Rage Italic/Aldine 721 BT

ISBN: 0-7643-1333-9
Printed in China

Published by Schiffer Publishing Ltd.
4880 Lower Valley Road
Atglen, PA 19310
Phone: (610) 593-1777; Fax: (610) 593-2002
E-mail: Schifferbk@aol.com
Please visit our web site catalog at **www.schifferbooks.com**
We are always looking for people to write books on new and related subjects. If you have an idea for a book, please contact us at the above address.

This book may be purchased from the publisher.
Include $3.95 for shipping. Please try your bookstore first.
You may write for a free catalog.

In Europe, Schiffer books are distributed by
Bushwood Books
6 Marksbury Ave. Kew Gardens
Surrey TW9 4JF England
Phone: 44 (0)20 8392-8585; Fax: 44 (0)20 8392-9876
E-mail: Bushwd@aol.com
Free postage in the UK. Europe: air mail at cost.
Please try your bookstore first.

This book is dedicated to all the children of Hawaii.

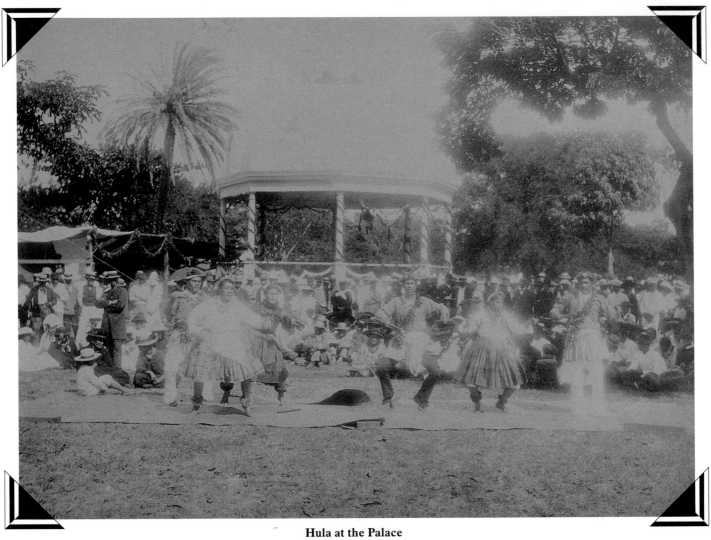

**Hula at the Palace**

# Preface

The photographs portrayed in this book have an amazing history and are quite important because of it. Two photograph albums recently were purchased in Northern California from Mrs. Jean Gifford, whose parents acquired the albums while living in Honolulu in the 1940s. Her parents obtained them from Queen Liliuokalani's personal nurse, whom they had befriended and who was living in Makaha, Oahu.

They related that the photographs were selected for and given, as a token of the Queen's Aloha, to the nurse who attended to her needs in the last years of her life. The majority of these photographs are quite unusual and have never been published or seen before.

The pictures appear to have been taken by several different photographers operating in Honolulu during the 1880s and 1890s. The majority seem to have been taken by Frank Davey and James J. Williams or were printed from negatives they obtained from other photographers.

What makes these photographs so fascinating – besides their Royal connection – is that they truly represent a long-bygone era. They were taken during a time when the Hula was in its revival, during the reign of King David Kalakaua, "The Merry Monarch." Before his reign, the Hula was outlawed in Hawaii and was in danger of being lost. David Kalakaua, however, was sympathetic to the long history of Hawaii's heritage and the Hula's place in it. The King took the oath of office on February 12, 1874, and reigned until his death in San Francisco, California, on January 20, 1891.

The first section of this book presents the life of Queen Liliuokalani illustrated with original photographs, photo postcards, cabinet card photographs, and cartes de visite photographs from the 1860s to 1917. The second section presents the Queen's special photograph album, as described above. In these photographs, Hawaiian Hula dancers and men, like the Queen, are captured with the poise and dignity of a time gone by. They truly represent the essence of Aloha spirit. It was fortuitous that these albums came my way.

Mark A. Blackburn

Kamuela, Hawaii

April, 2001

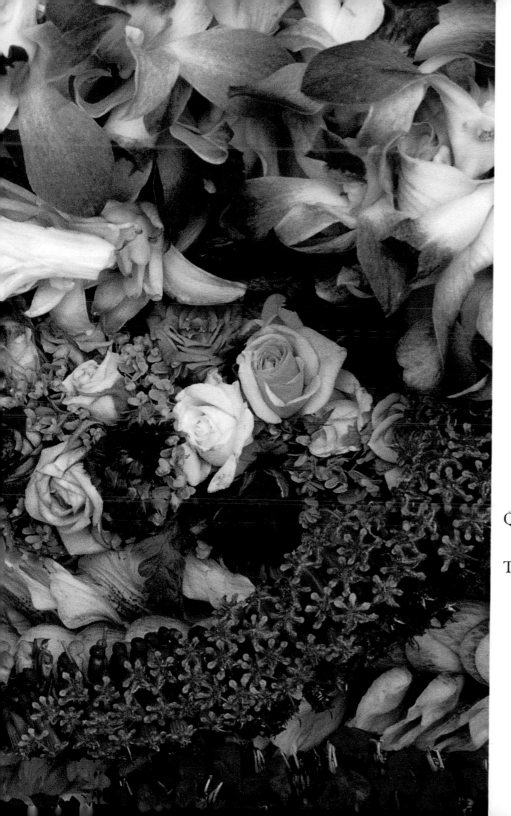

# Contents

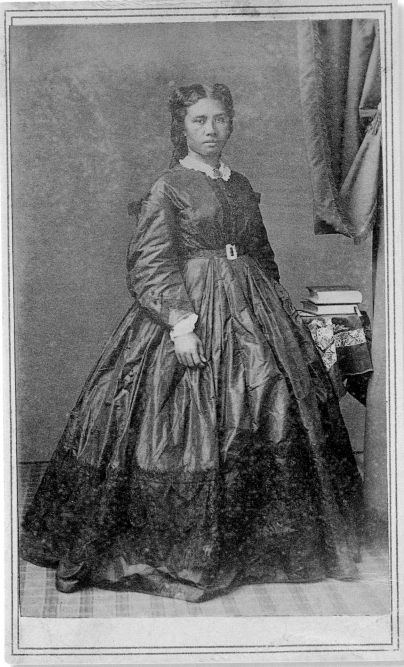

**Carte de Visite Photograph by H. L. Chase, Fort Street, Honolulu, H.I.**
Inscribed on reverse in pencil, *Mrs. Gov. Dominis or Kamakaeha*. Circa 1860s.

# Queen Liliuokalani (1839 -1917)

Queen Lydia Kamakaeha Kaolamalii was born in Honolulu in 1839, one of seven children of Kapaakea and his wife, Keohokalole. From a family that she later claimed was distantly connected to the father of Hawaii's King Kamehameha the First, she had several noteworthy siblings, including her brothers David Kalakaua and William Pitt Leleiohoku and her sister Miriam Likelike. They all attended the Royal School where they obtained a good education.

At the age of twenty-three, Lydia married John Owen Dominis, the wealthy son of a Mediterranean ship captain who had prospered in the Northwest Coast trade. He had spent time in San Francisco during the gold rush and later moved to Honolulu, where he worked for several years as a ship chandler for the firm of R. Cody and Company. A short time after their marriage, John Dominis was made Governor of Oahu, where the couple lived at his mother's home, Washington Place. It was so-named by Anthony Ten Eyck, who was the United States Legation and had formerly rented the home from Dominis.

Liliuokalani was greatly loved and admired by the Hawaiian people both at this time and throughout King David Kalakaua's world tour. Childless, the King made his sister the heiress apparent in 1877, after the death of their musically and poetically gifted brother William Pitt Leleiokhoku, who died of pneumonia at the age of forty-two. Liliuokalani, a world traveler like her brother the King, went to London in 1887 to attend Queen Victoria's jubilee with her sister-in-law, Queen Kapiolani.

A strong-willed woman, Lydia firmly believed in the rights of royalty and, as such, was active and outspoken in all such matters. In fact, it was Liliuokalani who named the Constitution of 1887 the "Bayonet Constitution," swearing that had she not been away in London at the time, her brother would never have signed his powers away.

In 1891, upon her brother's death, she was proclaimed Queen on January 29. She was anxious to restore the old order that was lost in 1887. Even though she had taken the oath to uphold the Constitution, she tried, without success, to replace it. In an indirect way, this led to her own bloodless overthrow on January 17, 1893.

After her monarchy was overthrown, she continued to obtain support from Robert W. Wilcox, who represented Honolulu in the legislature in 1890, and Kooluauloa as head of the Liberal Party. When a counter-revolution was staged in 1895, a small arsenal was uncovered

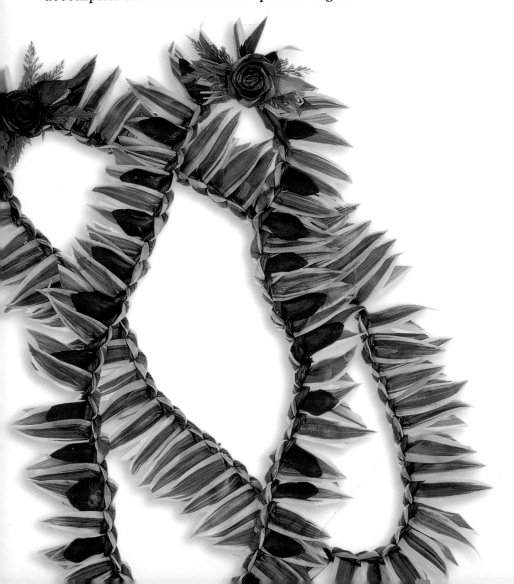

at Washington Place for which she was held responsible and she was placed under house arrest, being detained in her palace. She eventually signed a formal abdication and pledged full allegiance to the new Republic of Hawaii. Fully understanding the power of public opinion in such matters, in 1898 she wrote a book about her life and her efforts to be reseated on the throne, *Hawaii's Story by Hawaii's Queen*, which was published in Boston. Although a moving and impassioned plea, it accomplished little toward her quest to regain the throne.

In a move that surprised everyone, Liliuokalani attended the celebration at the opening of Pearl Harbor Naval Base in 1911, sitting with her old enemy and successor, Sanford B. Dole. He was instrumental in the "Bayonet Revolution" of 1887, as well as the first President of the Provisional Government. This act demonstrated to many her noble dignity that continued to grace her throughout her life. In a show of support for the United States shortly before her death in 1917, she flew the American flag over Washington Place for the first time, announcing her loyalty during the First World War.

Among many other accomplishments, Queen Liliuokalani may best be remembered as the author of numerous songs, including her most moving tune *Aloha Oe*.

*Opposite page*
*Left:* **Original Albumen Photograph by H. L. Chase, Fort Street, Honolulu, H.I.** Circa 1870.

*Right:* **Carte de Visite Photograph.** W. Dickson, Honolulu. Inscribed on reverse in pencil, *Hon. Mrs. Dominis*. Circa 1870.

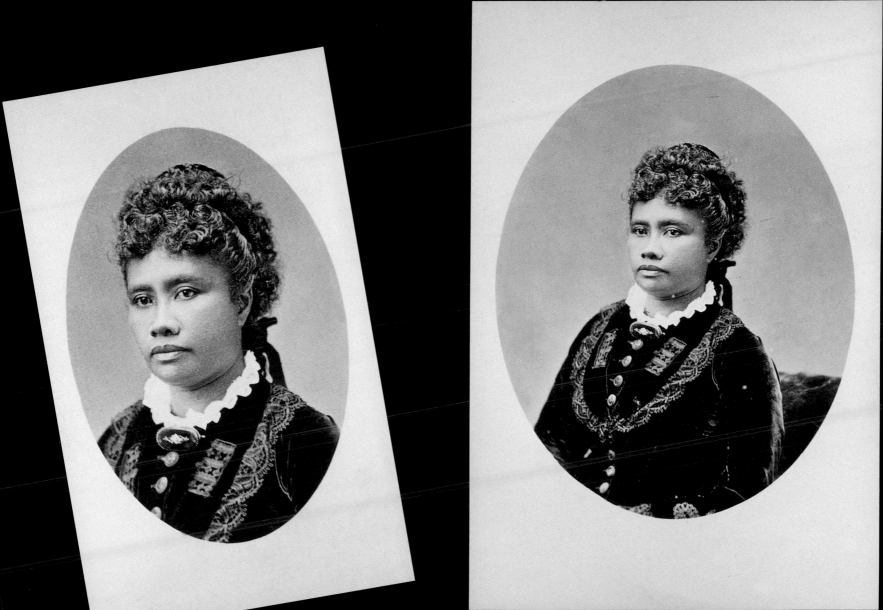

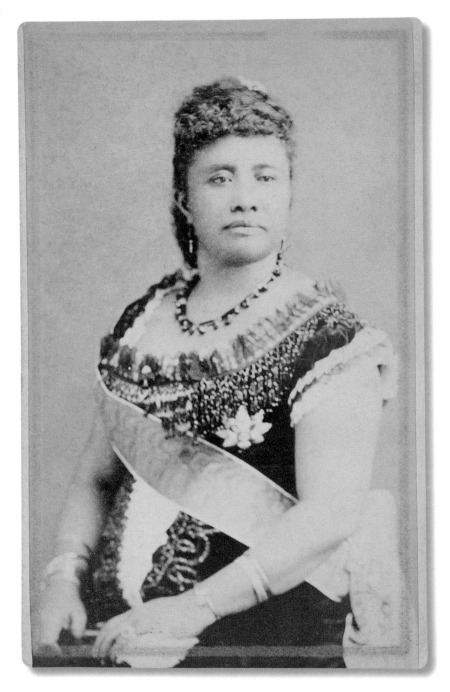

**Carte de Visite Photograph.** A. A.
Montano, Honolulu, H.I. Inscribed on
reverse in pencil, *Princess Lilua Dominis*.

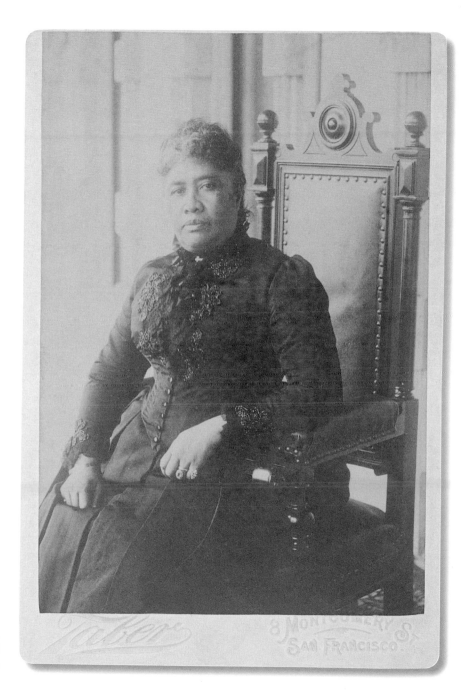

**Cabinet Card Photograph by Taber, San Francisco, California.** One of the earliest known dated portraits of the Queen, March 21, 1891.

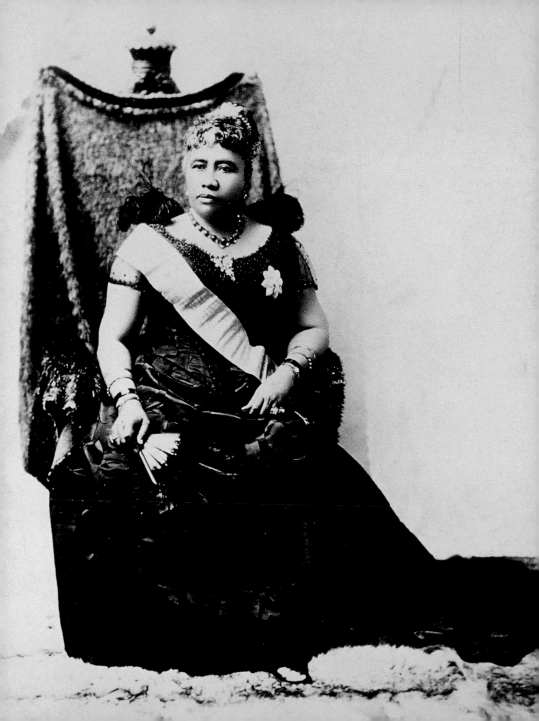

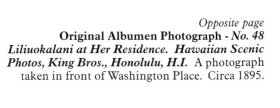

*Opposite page*
**Original Albumen Photograph -** *No. 48*
*Liliuokalani at Her Residence. Hawaiian Scenic Photos, King Bros., Honolulu, H.I.* A photograph taken in front of Washington Place. Circa 1895.

**Original Albumen Photograph.** Inscribed on reverse in pencil, *Princess Lilly, Hawaiian Island.* Circa 1890s.

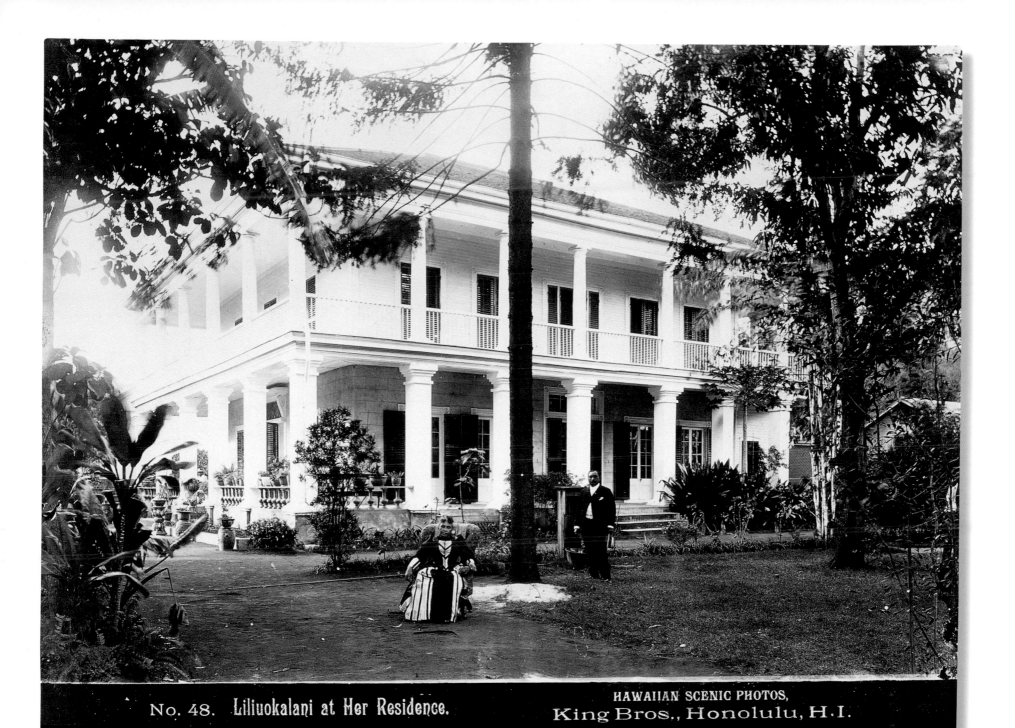

No. 48.    Liliuokalani at Her Residence.

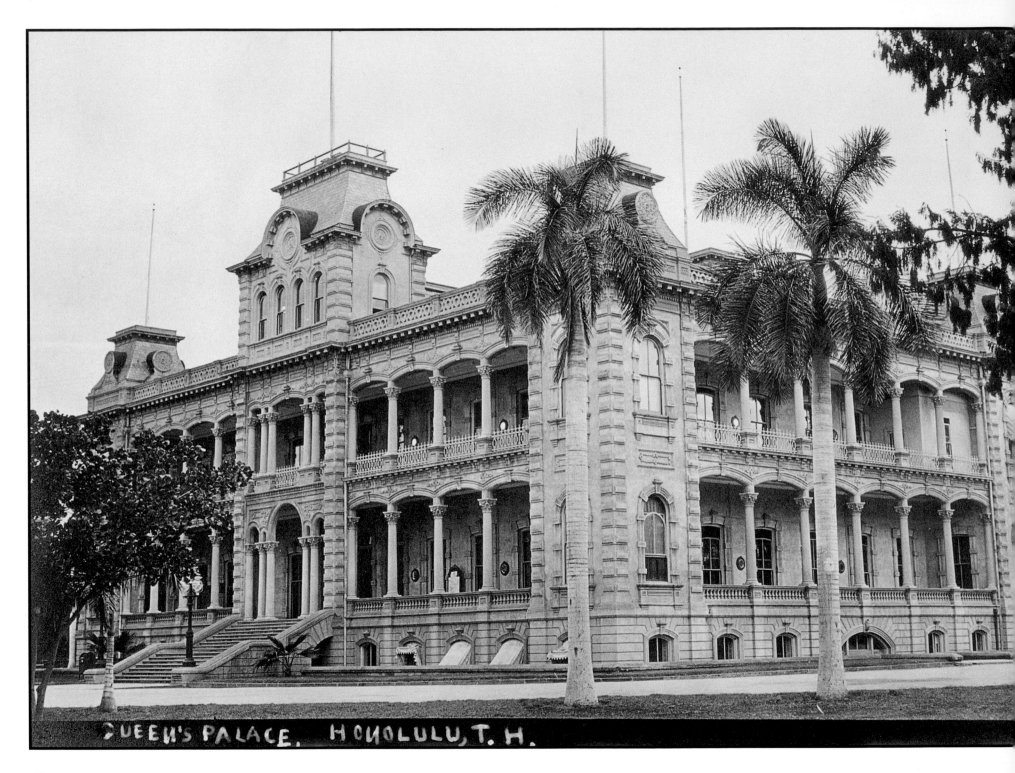

QUEEN'S PALACE. HONOLULU, T. H.

**Photograph - *Queen's Palace, Honolulu, T.H.*** Original photo by Frank Davey. Circa 1900.

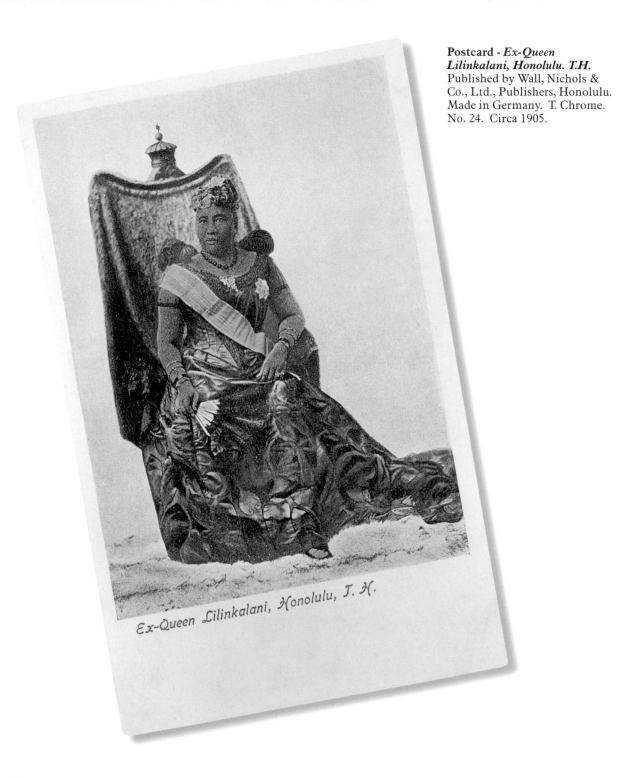

Postcard - *Ex-Queen Lilinkalani, Honolulu. T.H.* Published by Wall, Nichols & Co., Ltd., Publishers, Honolulu. Made in Germany. T. Chrome. No. 24. Circa 1905.

*Ex-Queen Lilinkalani, Honolulu, T. H.*

**Postcard - *H. M. Queen Liliuokalani – Hawaii*.** Aloha Nui Series published in Germany for Hawaii & South Seas Curio Co., Honolulu. Hand-colored, circa 1905.

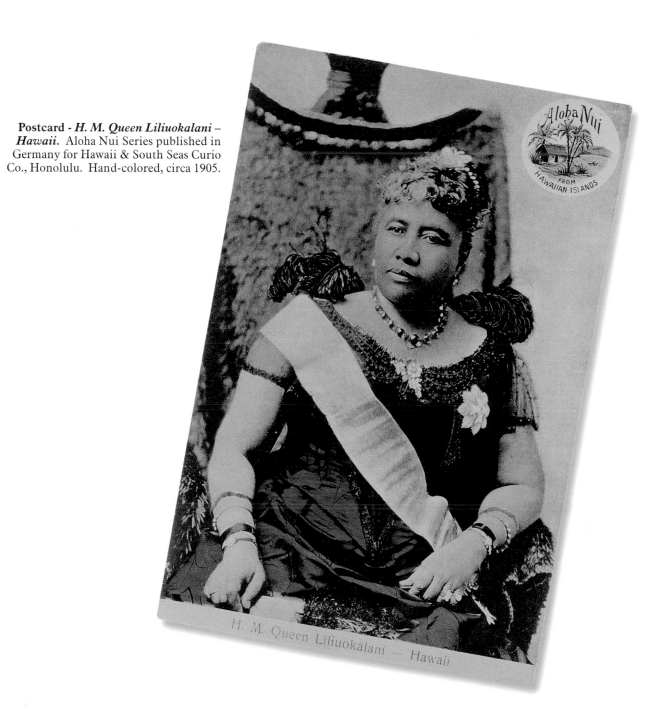

Aloha Nui
FROM
HAWAIIAN ISLANDS

H. M. Queen Liliuokalani — Hawaii

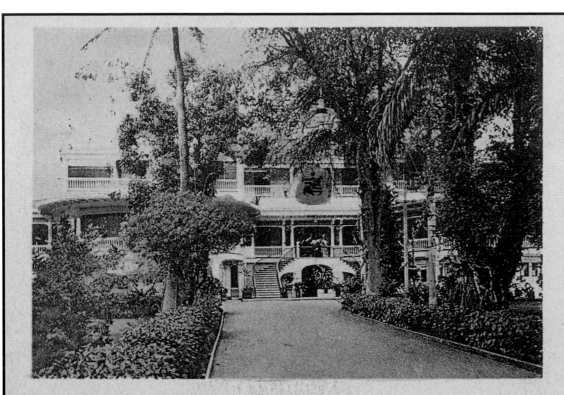

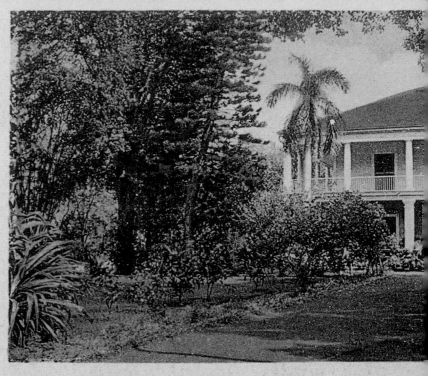

**Royal Hawaiian Hotel**

**Queen's Residence, Honol**

We are sitting in the garden of the listening to the band of
24th infantry, playing delightfully we lunched at
Aloha Nui out on the Waikiki beach & afterward w
up to the Aquarium where we saw th
wonderful shapes & shades of fish th
were created, We sail this afternoon
oclock & expect to arrive

Hawaii & South Seas Curio Co., Honolulu. No. 35

FROM HAWAIIAN ISLANDS

**Postcard - *Royal Hawaiian Hotel* and *Queen's Residence, Honolulu.*** Aloha Nui Series published in Germany for Hawaii & South Seas Co., Honolulu. No. 35. Circa 1905.

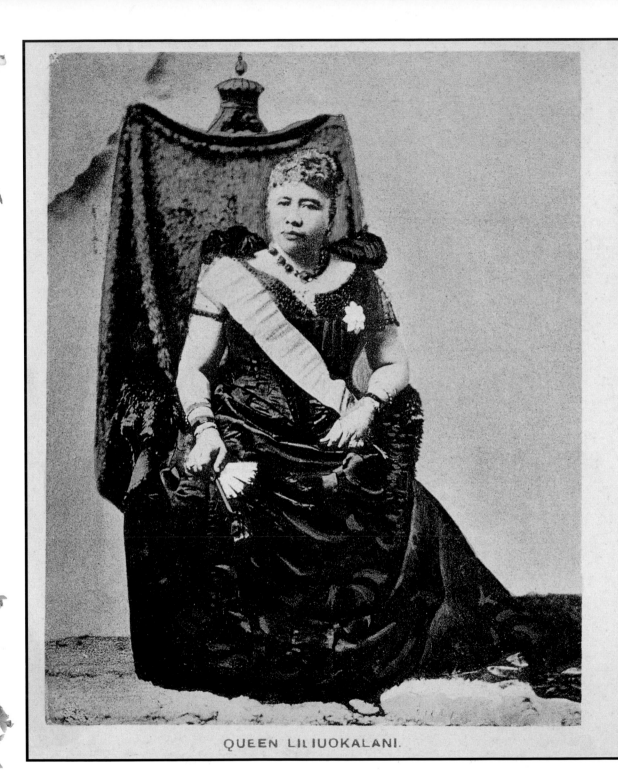

QUEEN LILIUOKALANI.

COAT OF ARMS.

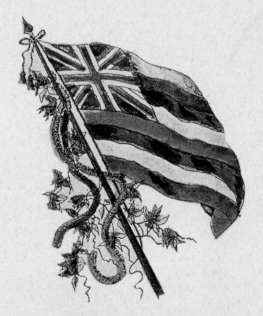

FLAG OF HAWAII.

*Germany*

No. 45.  Hawaii &

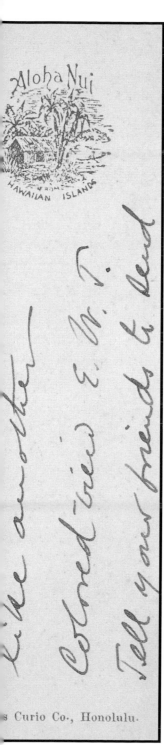

**Postcard -** *Queen Liliuokalani, Royal Coat of Arms and Flag of Hawaii.* Aloha Nui Series published in Germany for Hawaii & South Seas Curio Co., Honolulu. Circa 1900.

**Postcard - #93. *Queen Liliuokalani and Princess Kalanianaole, Honolulu.*** Aloha Nui Series published in Germany for Hawaii & South Seas Curio Co., Honolulu. From an original photograph taken during the annexation ceremonies of August 12, 1898. Circa 1905.

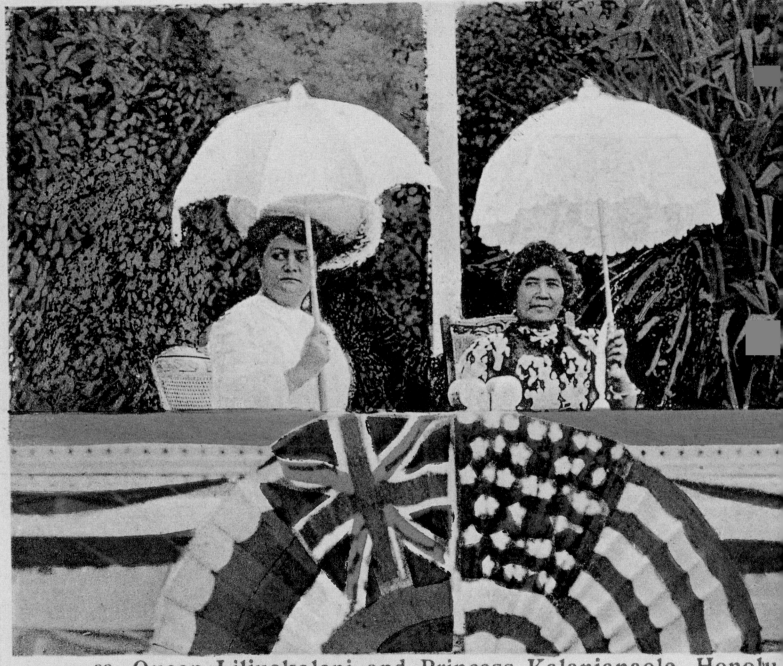

93. Queen Liliuokalani and Princess Kalanianaole, Honolu

QUEEN of HAWAII AND Royal Family on Board U.S.S. CALIFORNIA. Pearl Harb 1911. T.H.

**Real Photo Postcard - *Queen of Hawaii and Royal Family on Board U.S.S. California, Pearl Harbor 1911 T.H.*** A very rare view taken at the opening ceremony of the Pearl Harbor Naval Base with Queen Liliuokalani seated with her old enemy and successor Sanford B. Dole.

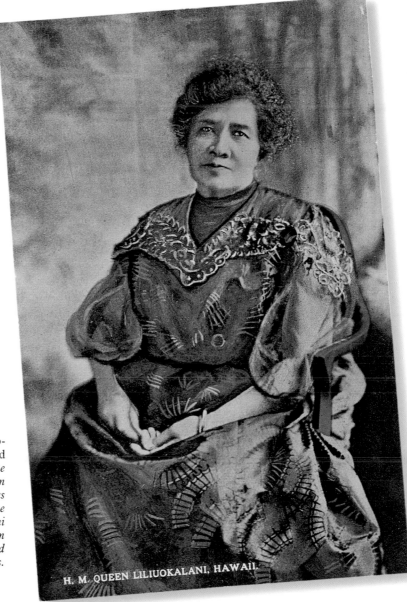

**Postcard - *H. M. Queen Liliuokalani, Hawaii.*** #93 Published by Hawaii & South Seas Curio Co., Honolulu. Printed on reverse as follows: *H. M. Queen Liliuokalani exceeded to the crown in 1891, and was desposed in 1893. In 1895 there was an insurrection for her restoration and during that year she was confined for nine months in her former Palace; during which time she formally denounced all her claims for the throne. Liliuokalani now resides at Washington Place, and receives a large annuity from the island government. She is a woman of gracious presence and greatly beloved by all her subjects.*

H. M. QUEEN LILIUOKALANI, HAWAII.

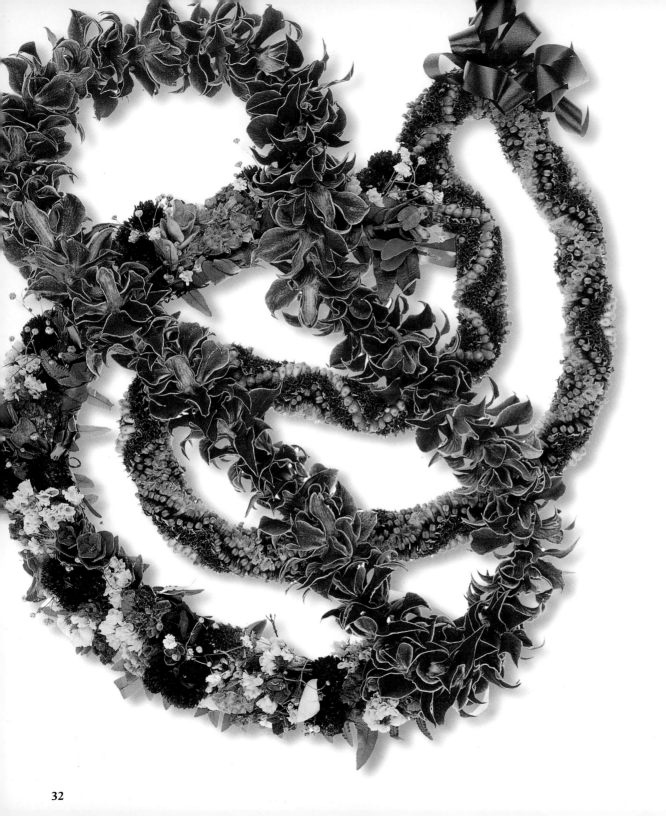

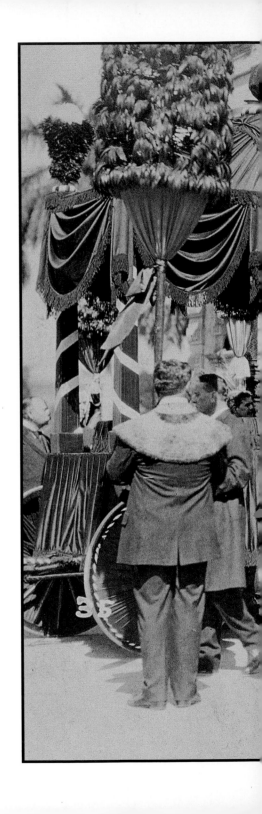

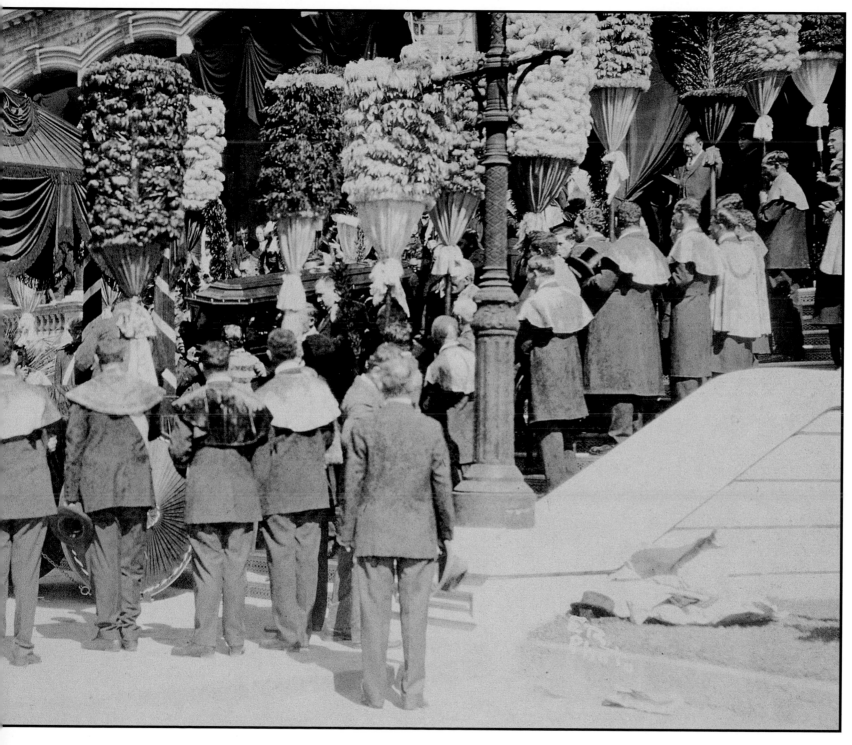

**Real Photo Postcard - #35 ETZ Photo.** A moving photograph of Queen Liliuokalani's funeral procession at the steps of Iolani Palace, the former residence of the Queen while she was in power. Circa November 11, 1917.

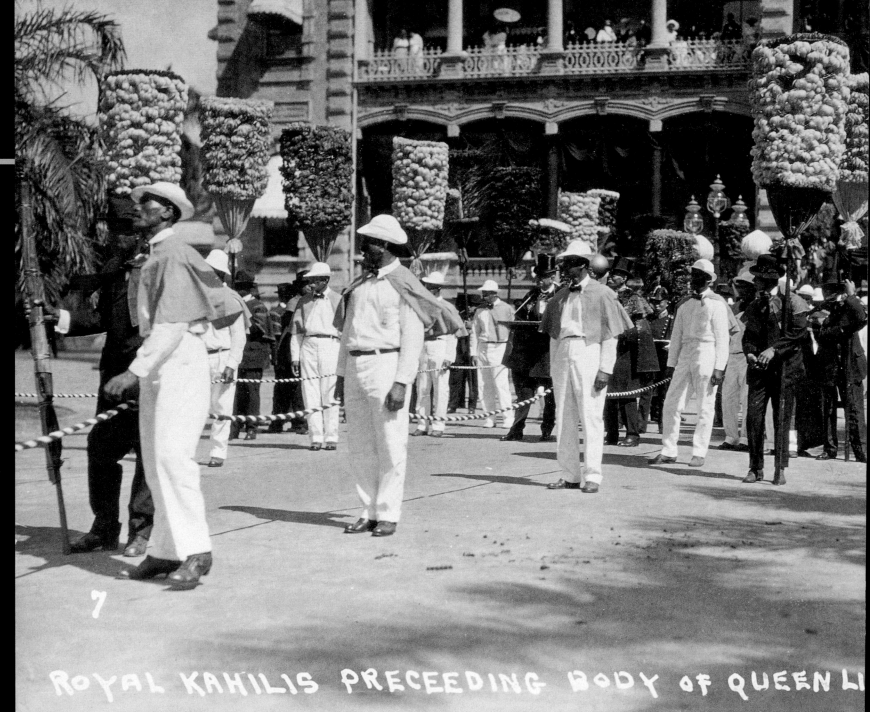

**Real Photo Postcard - #7** *Royal Kahilis Preceeding Body of Queen Liliokalani* **ETZ Photo.** Procession is moving from the front of Iolani Palace to Kawaiahao Church. Circa November 11, 1917.

ROYAL KAHILIS PRECEEDING BODY OF QUEEN LI

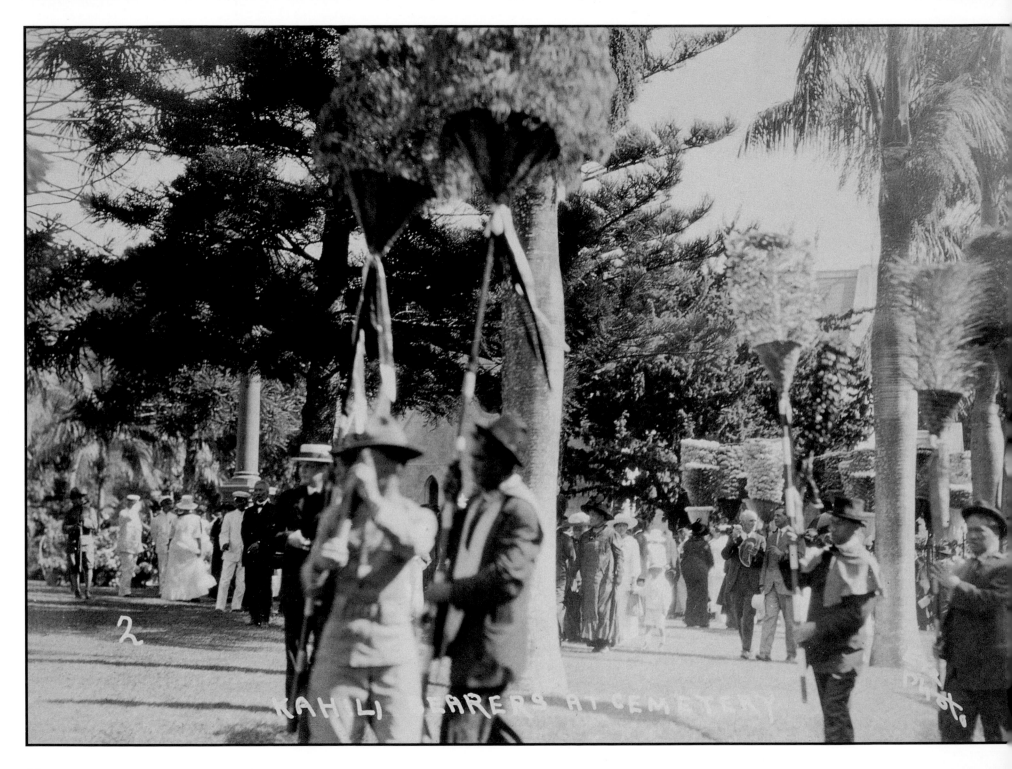

KAHILI BEARERS AT CEMETERY

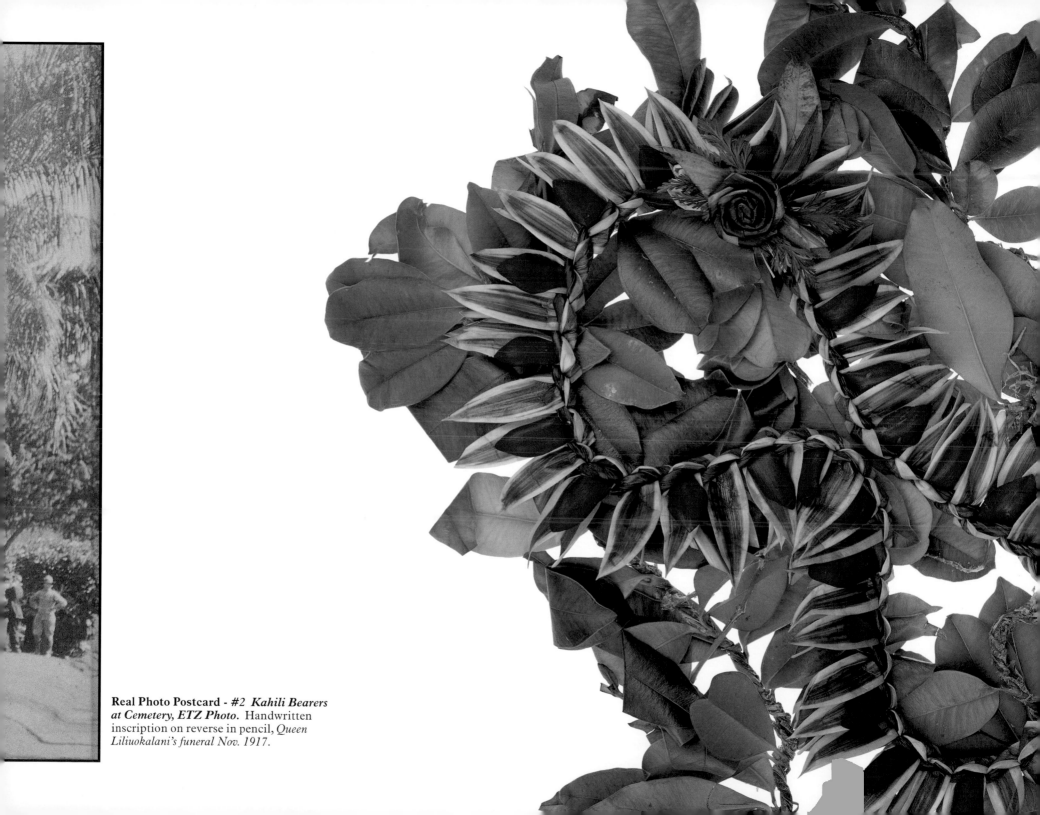

**Real Photo Postcard - #2 Kahili Bearers at Cemetery, ETZ Photo.** Handwritten inscription on reverse in pencil, *Queen Liliuokalani's funeral Nov. 1917.*

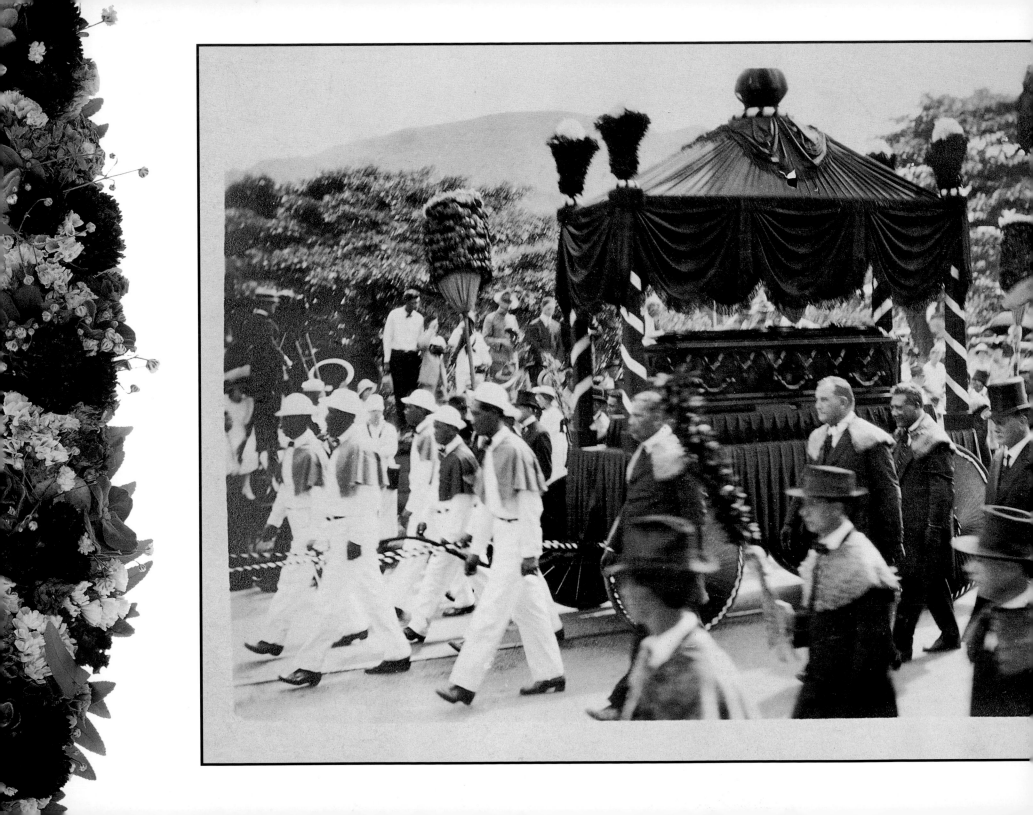

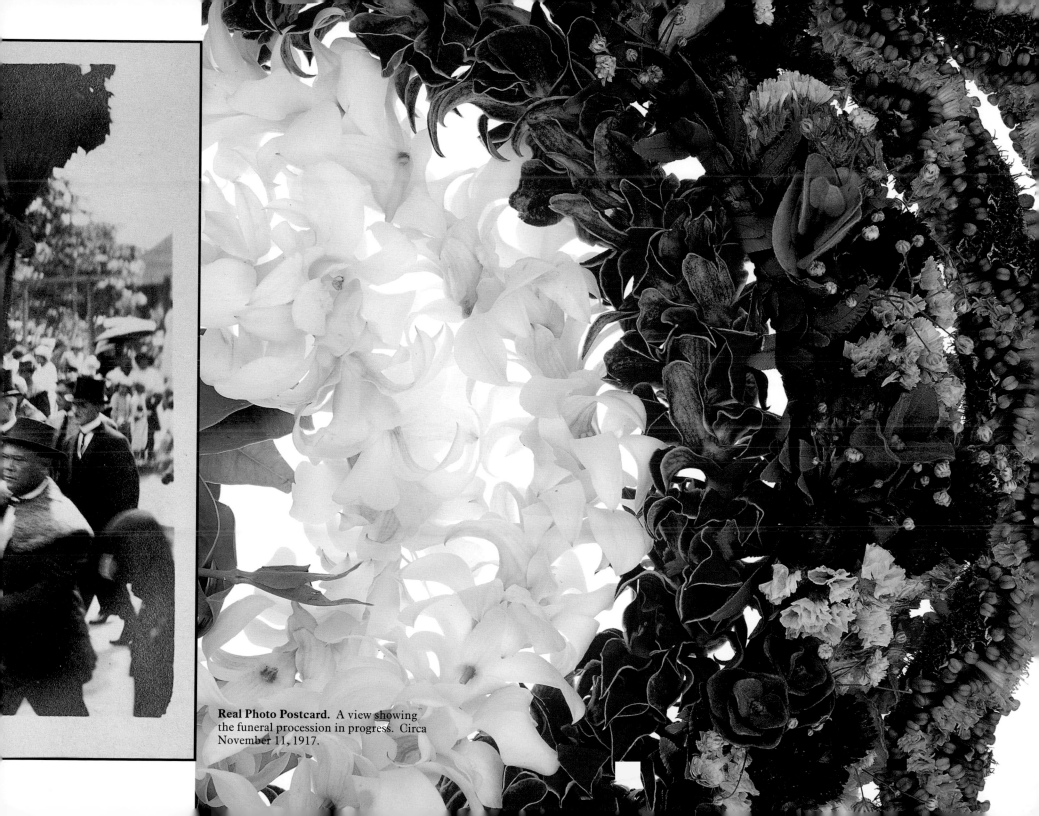

**Real Photo Postcard.** A view showing the funeral procession in progress. Circa November 11, 1917.

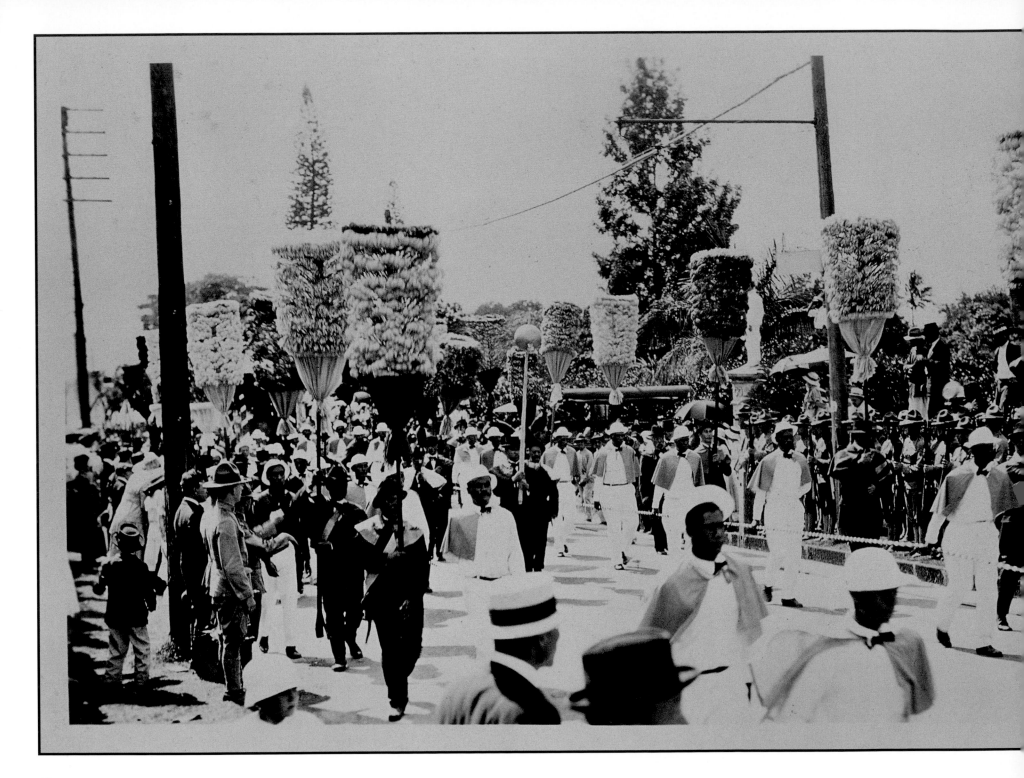

**Original Photograph.** Inscribed on reverse in pencil, *Queen Liliuokalani's funeral (The last of the Royal Family).*

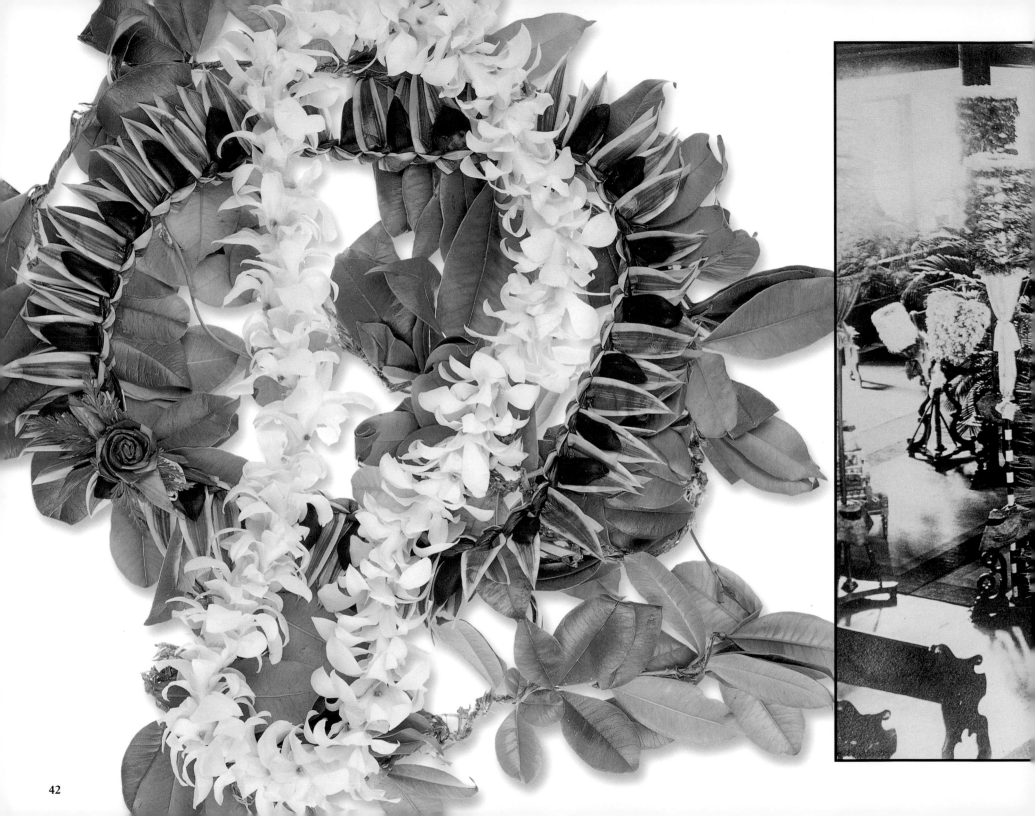

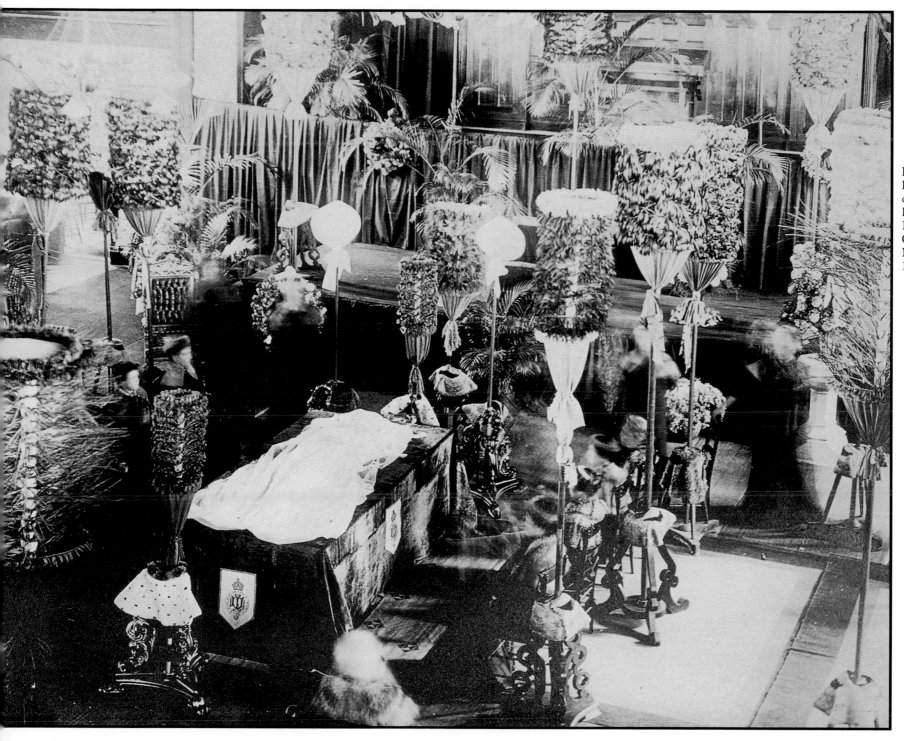

**Real Photo Postcard.** Image of the Queen lying in state in Kawaiahao Church. Circa November 11, 1917.

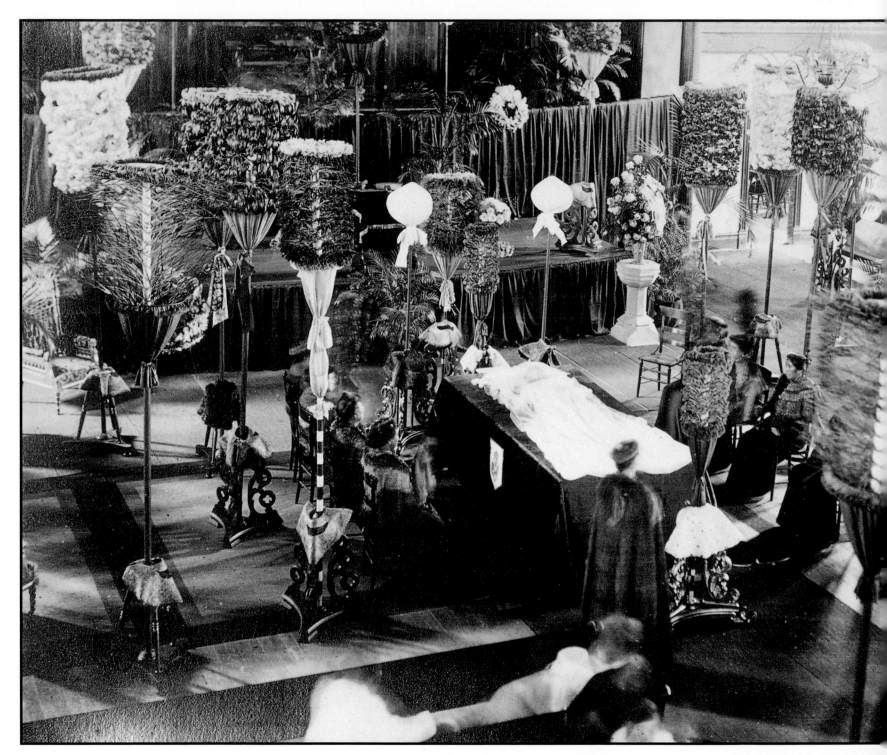

**Real Photo.**
Image of the Queen lying in state in Kawaiahao Church. Circa November 11, 1917.

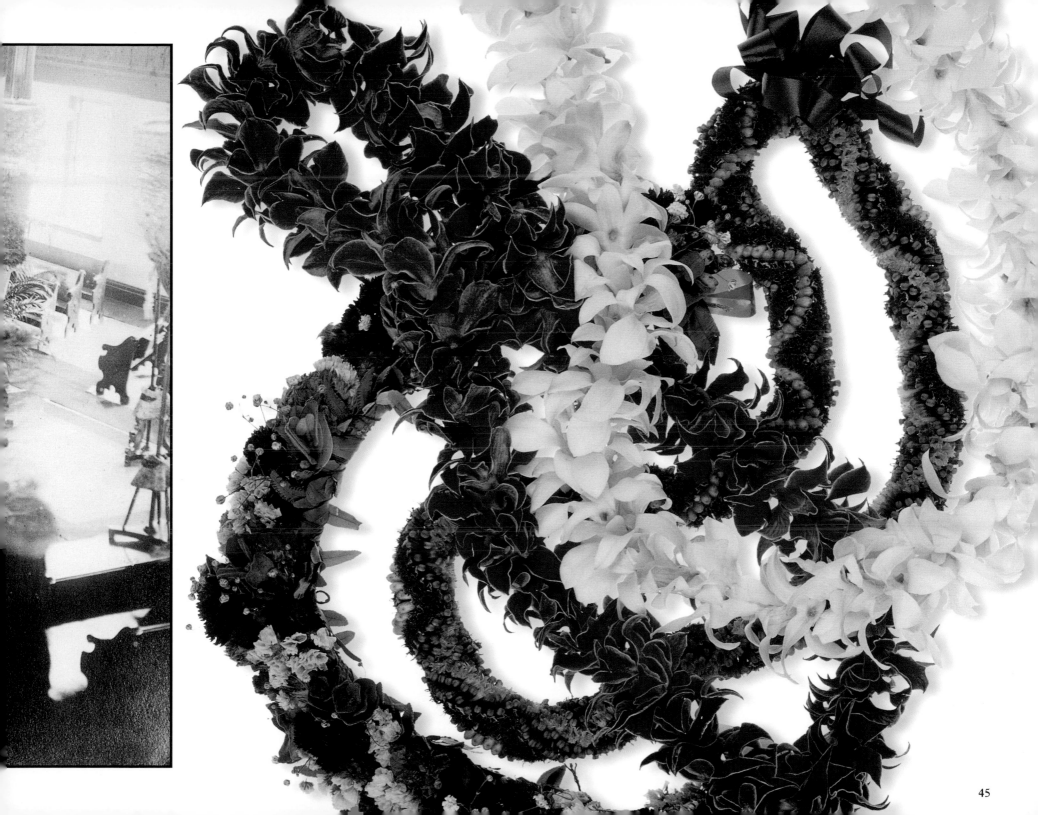

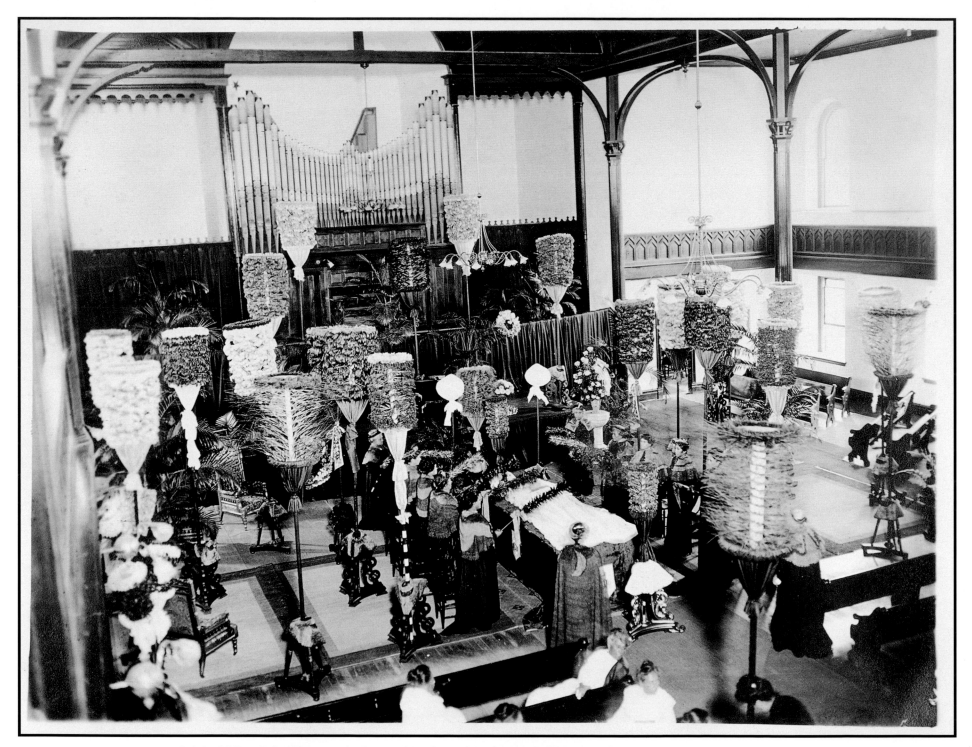

**Original Silver Print Photograph.** Image of the Queen lying in state in Kawaiahao Church. Circa November 11, 1917.

# The Album

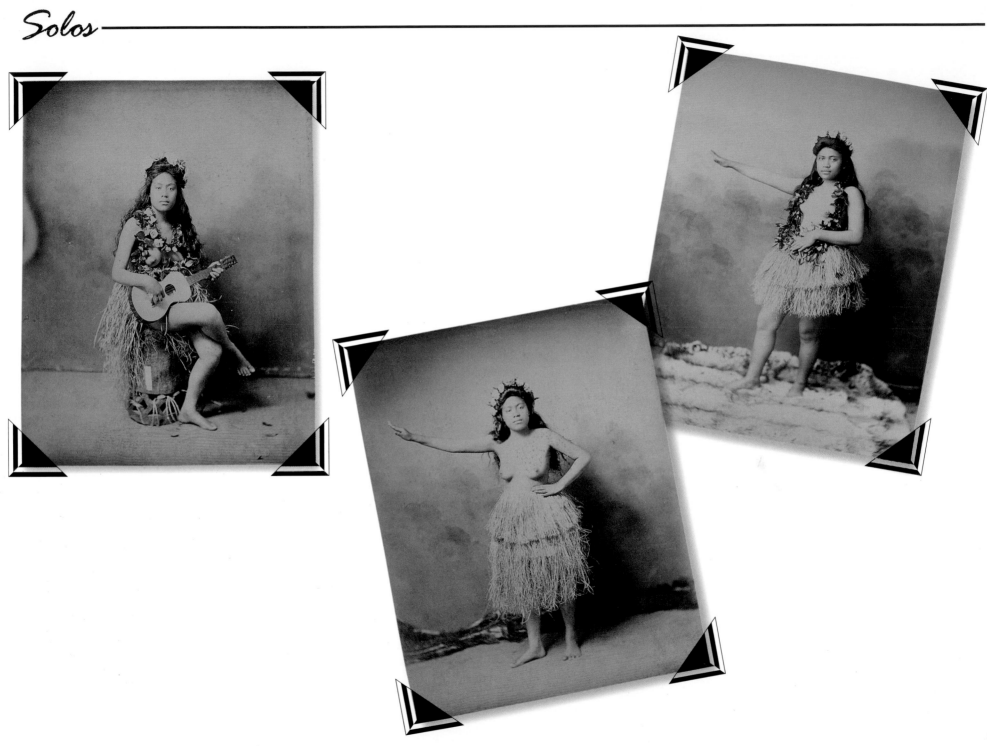

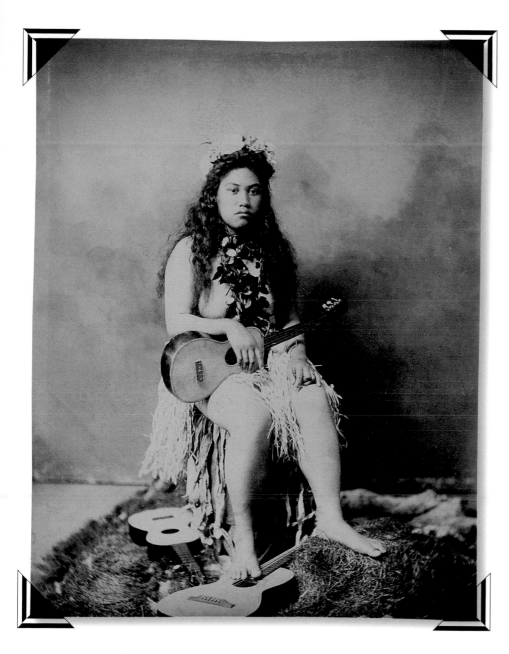

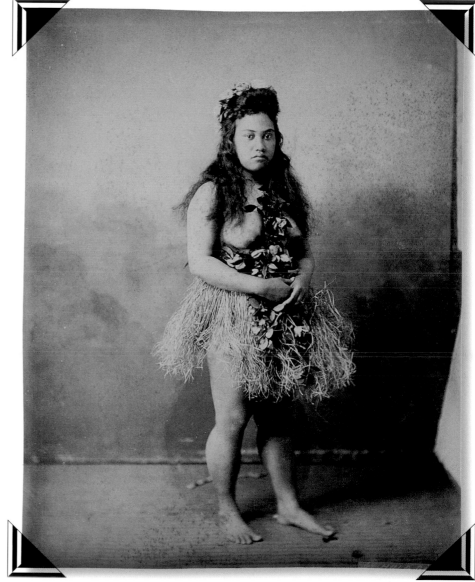

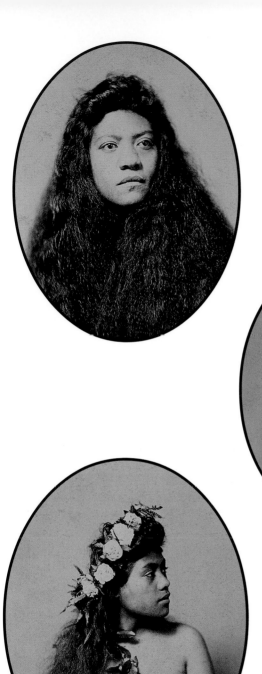

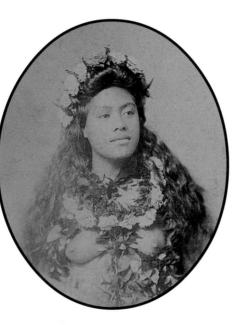

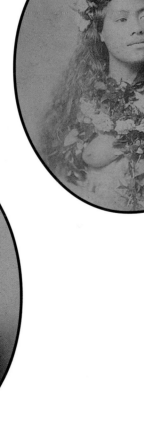

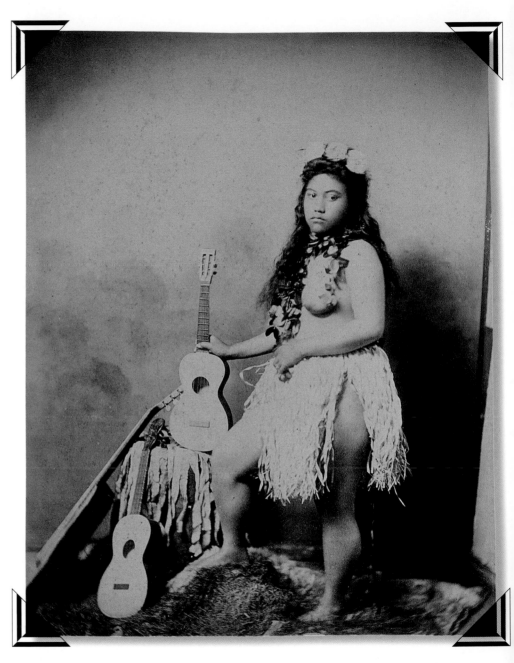

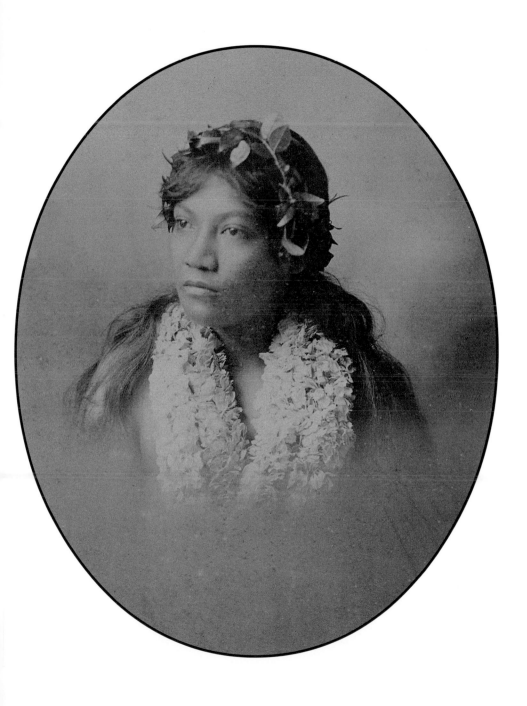

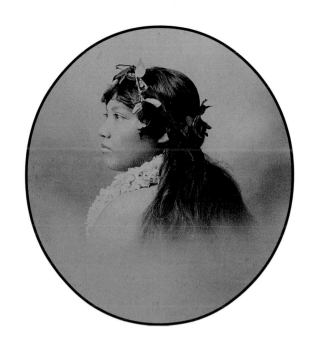

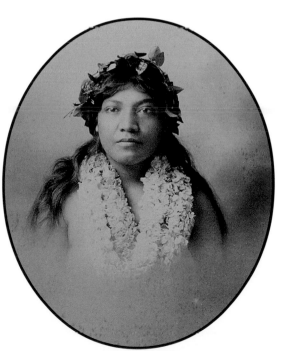

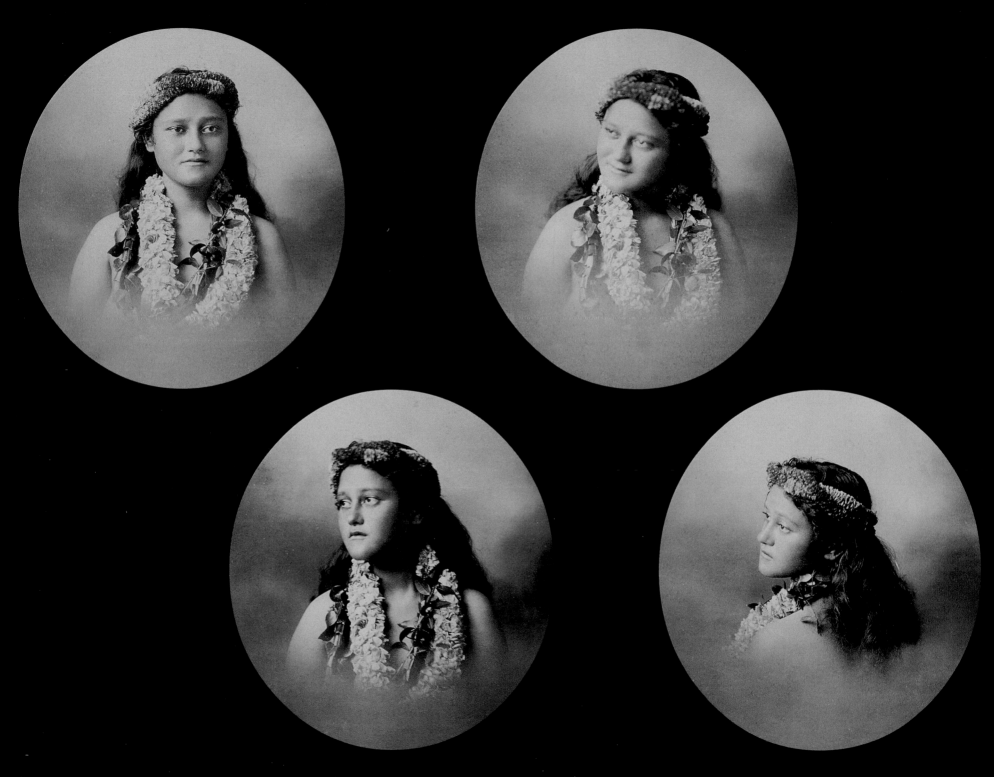

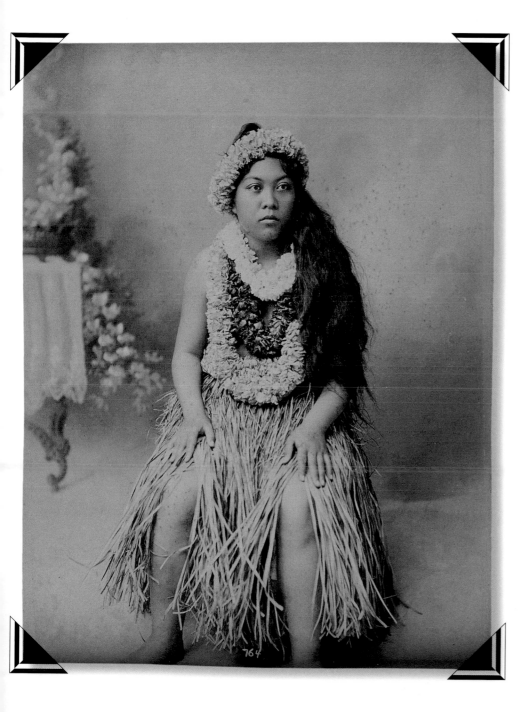

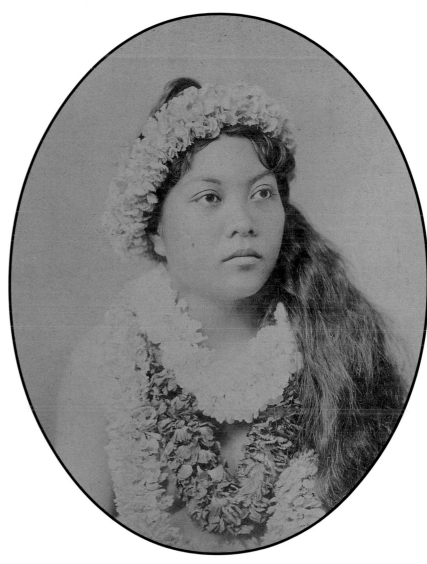

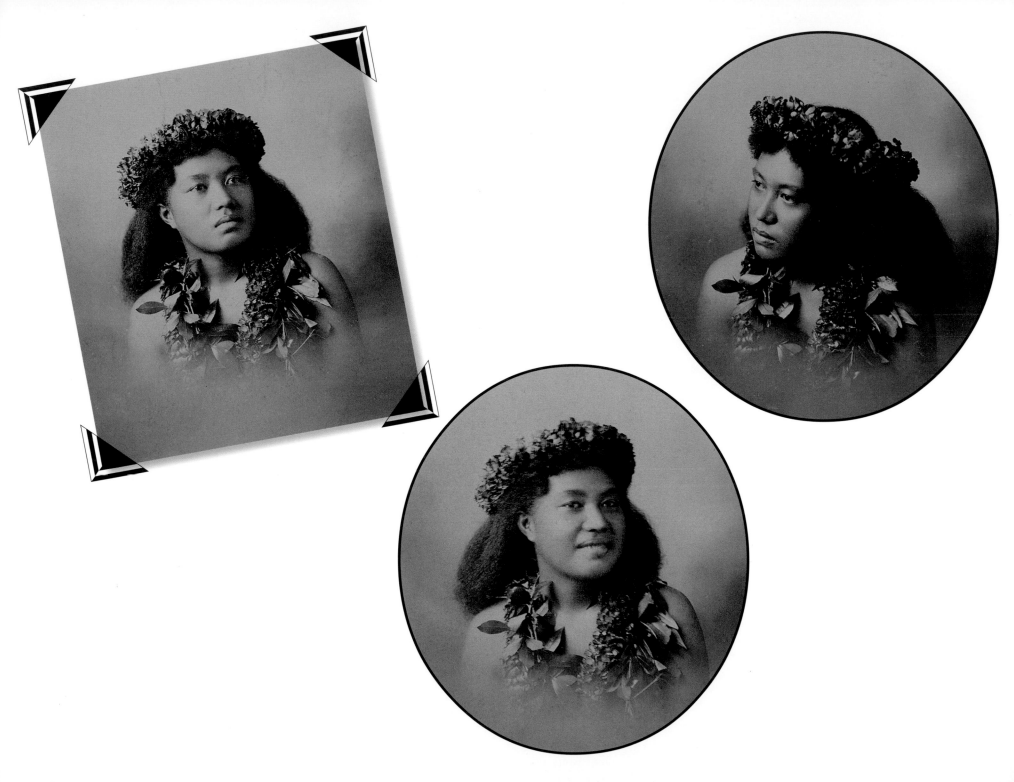

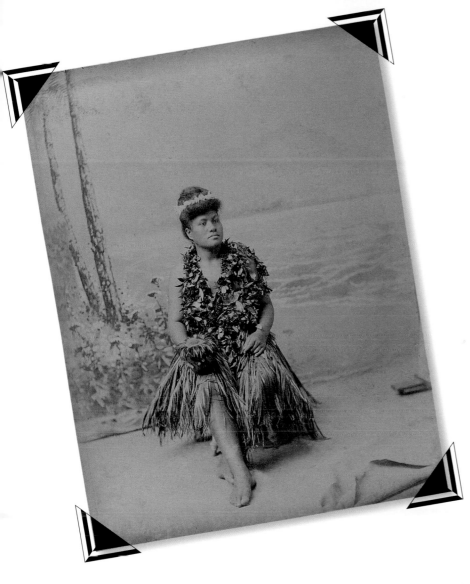

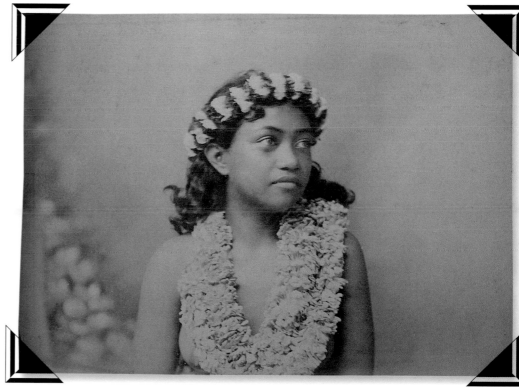

55

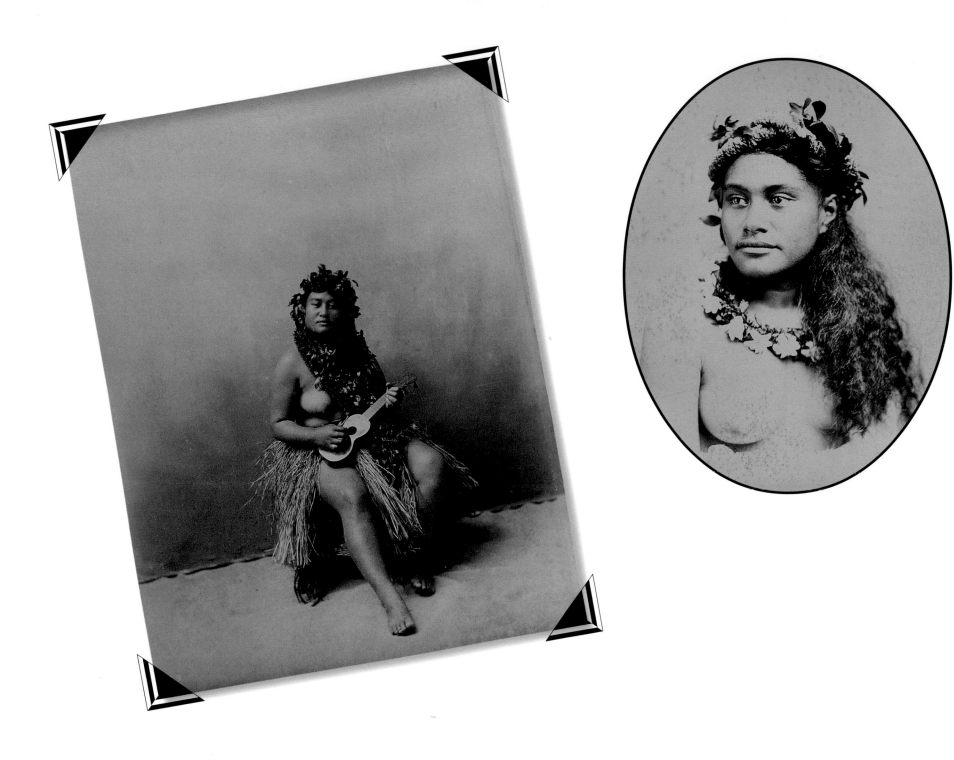

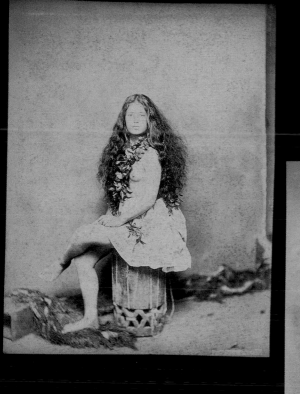
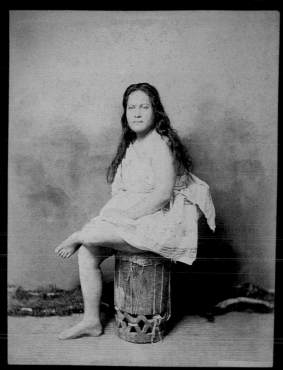
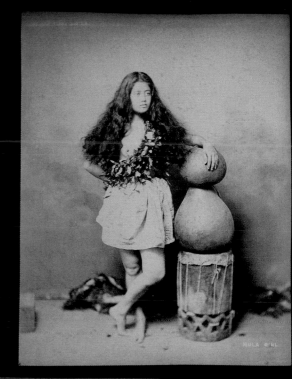
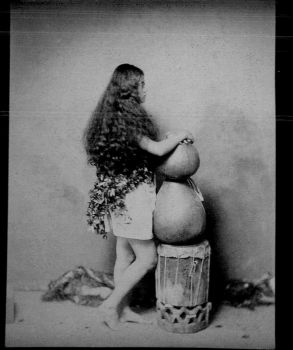

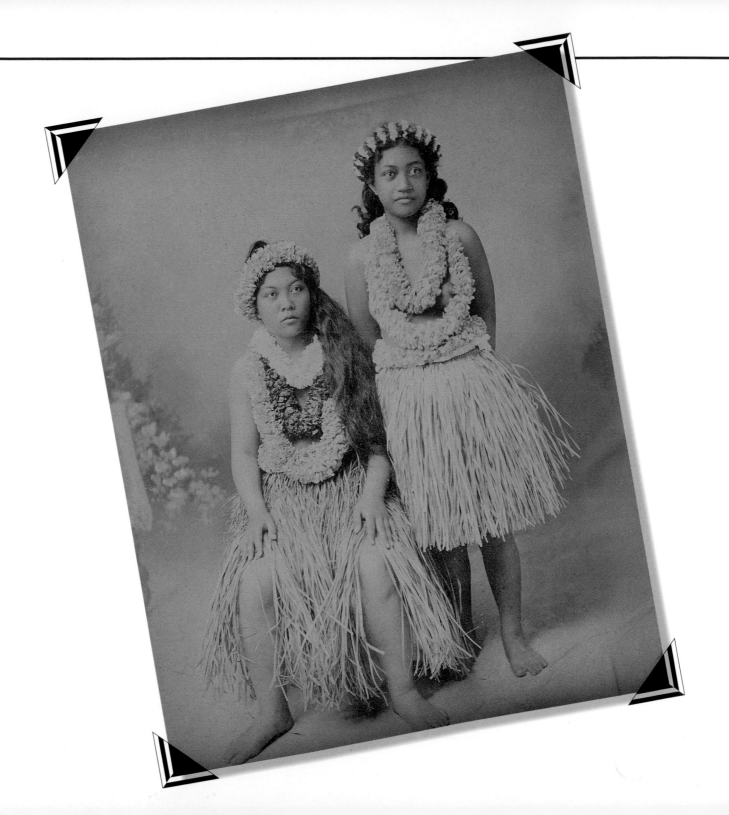

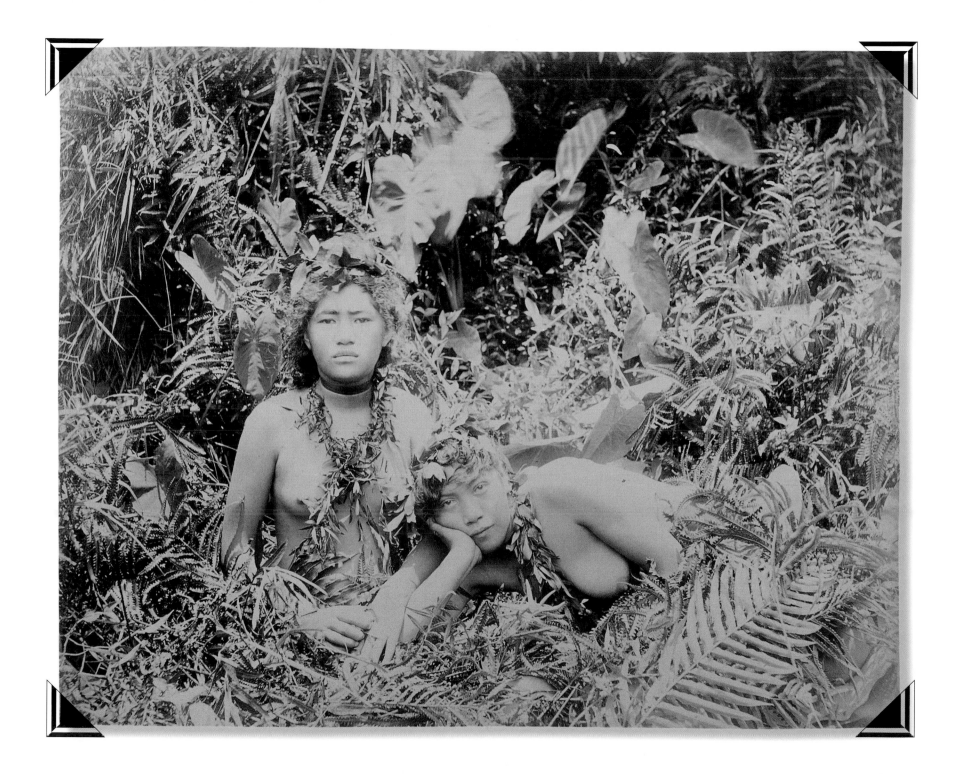

59

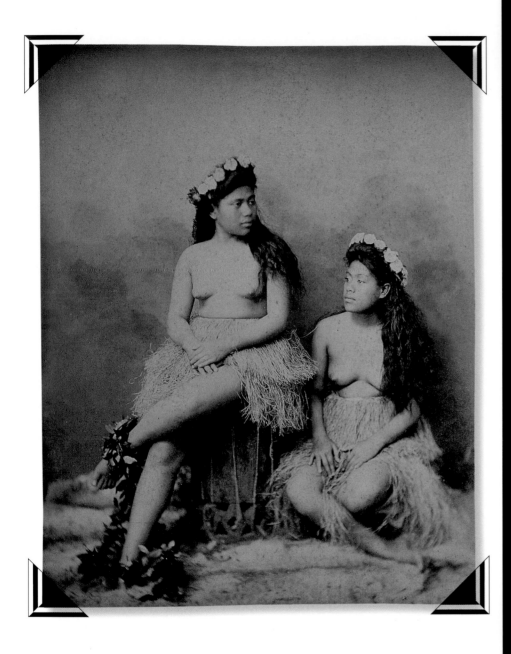

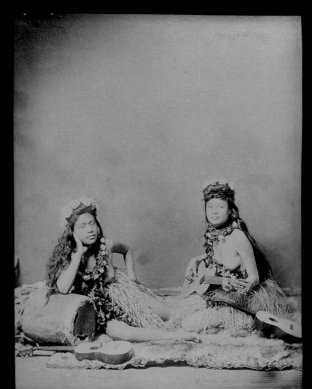

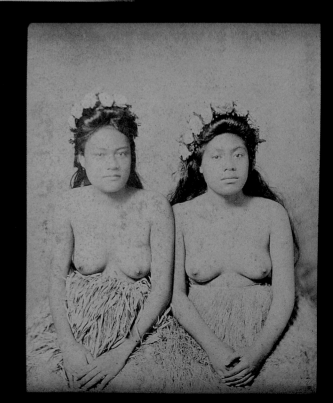

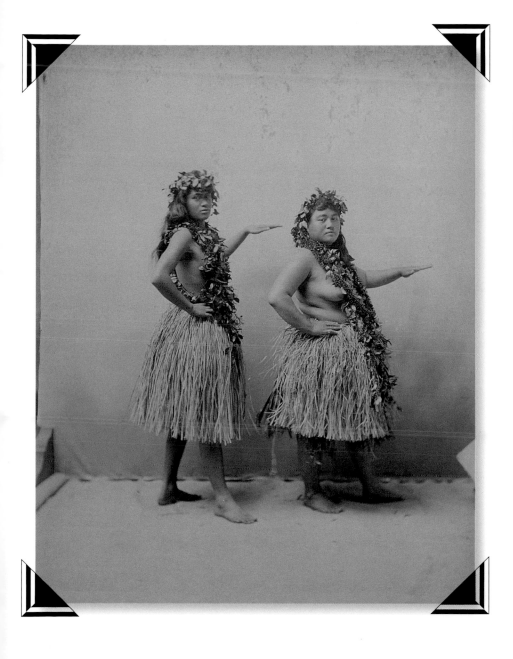

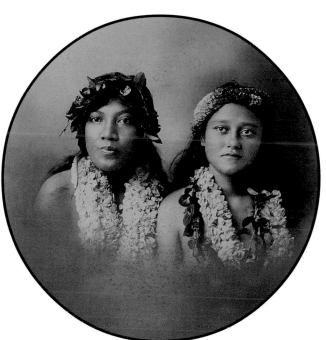

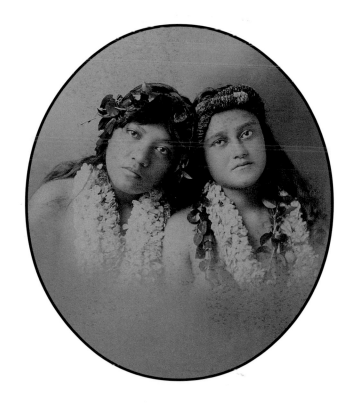

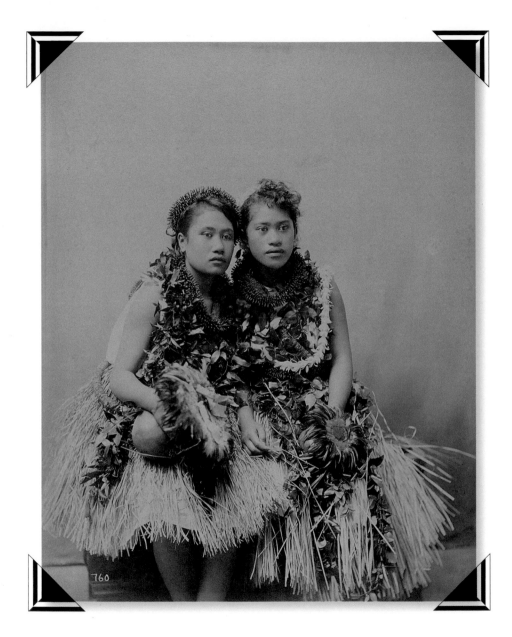

760

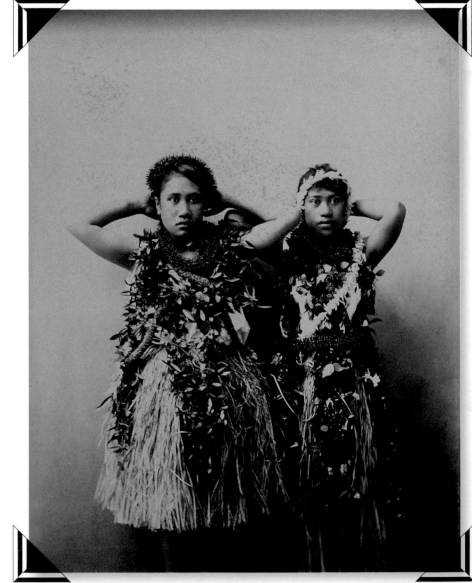

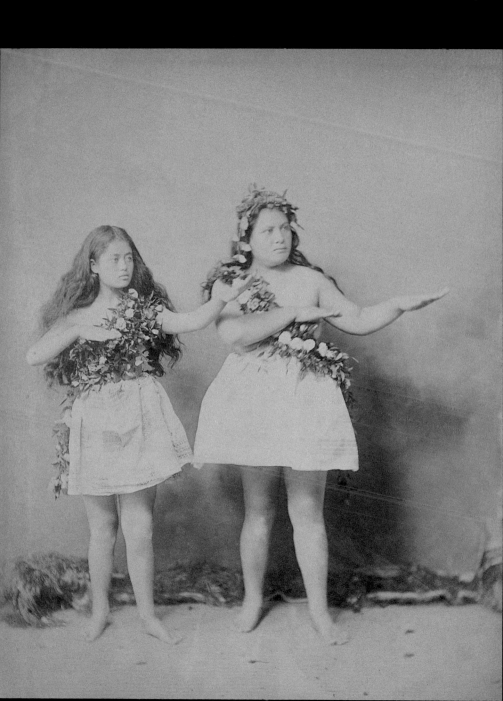

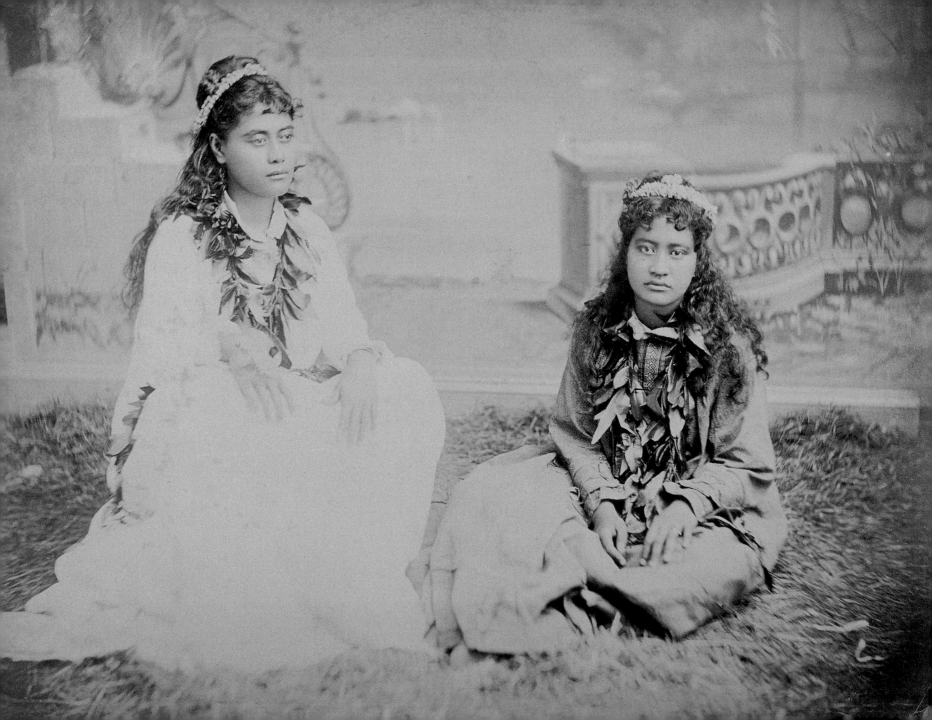

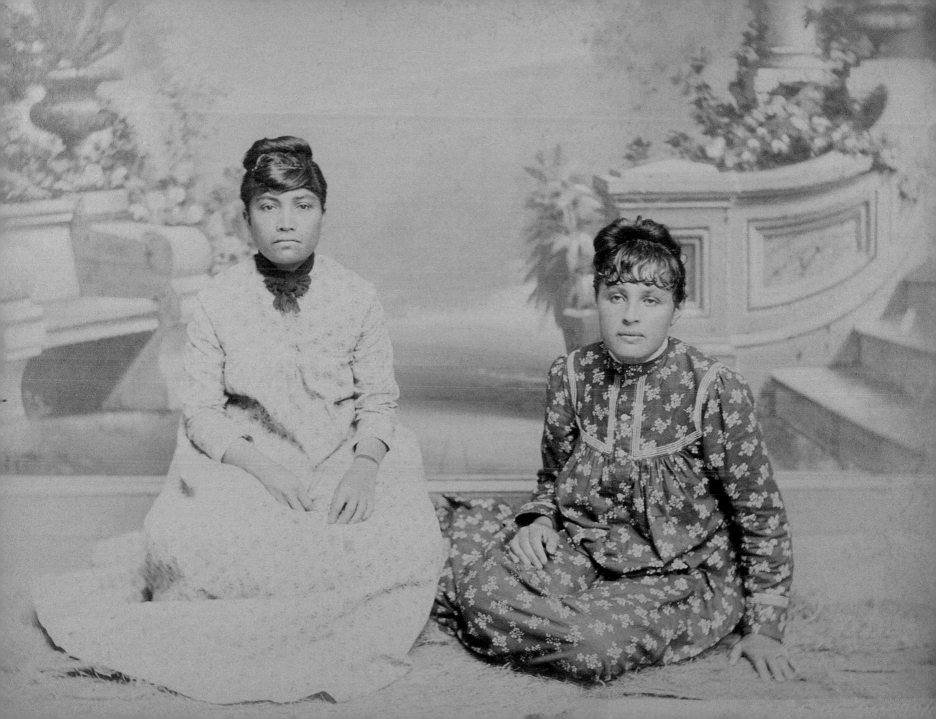

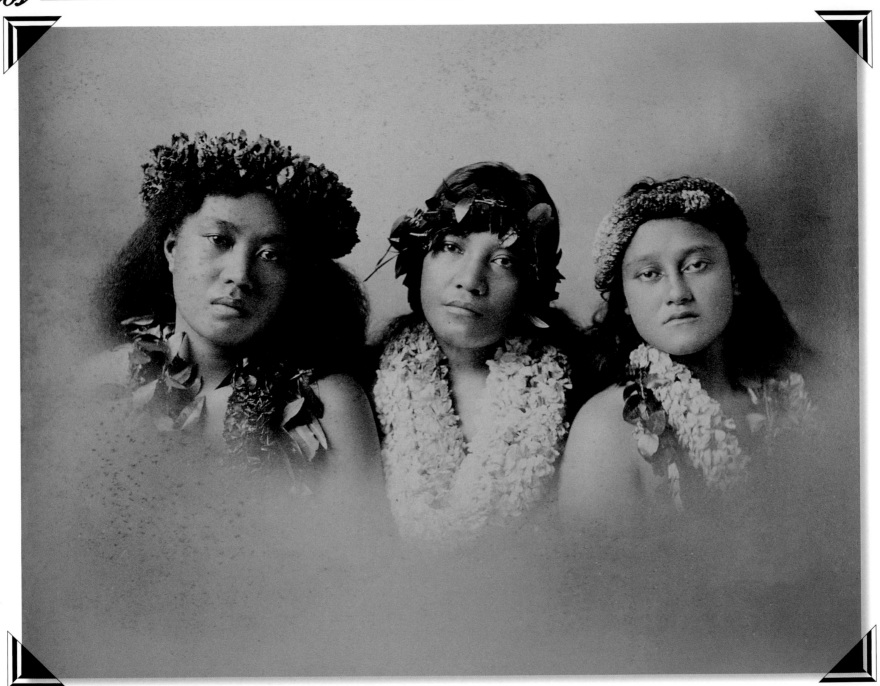

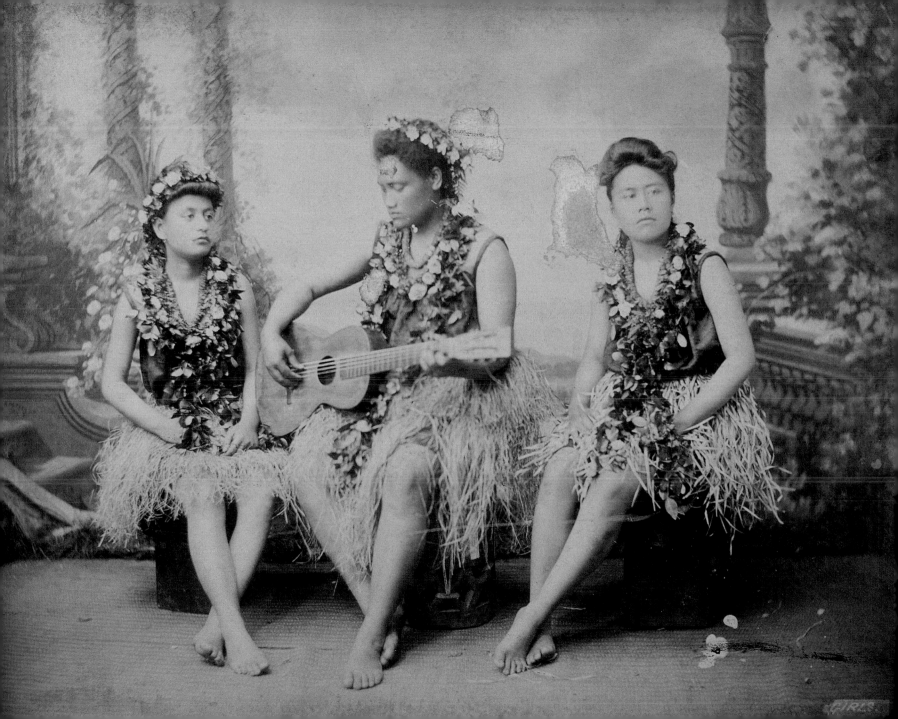

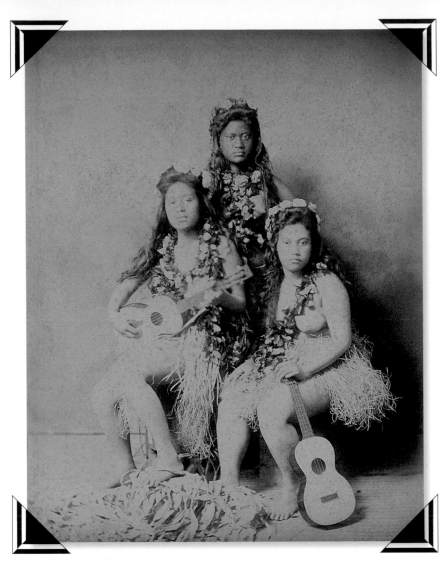

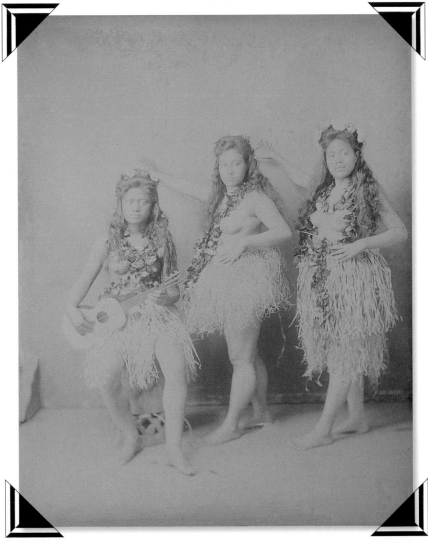

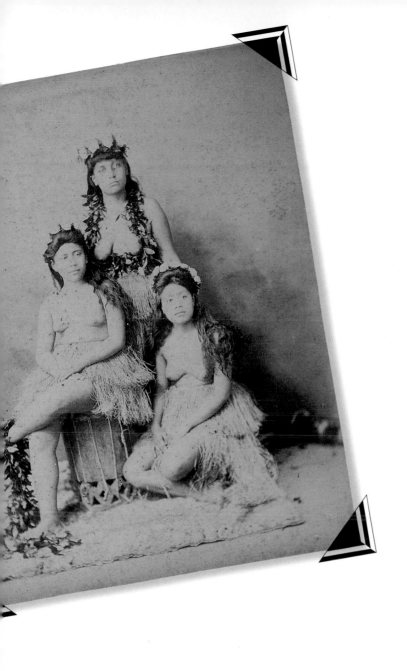

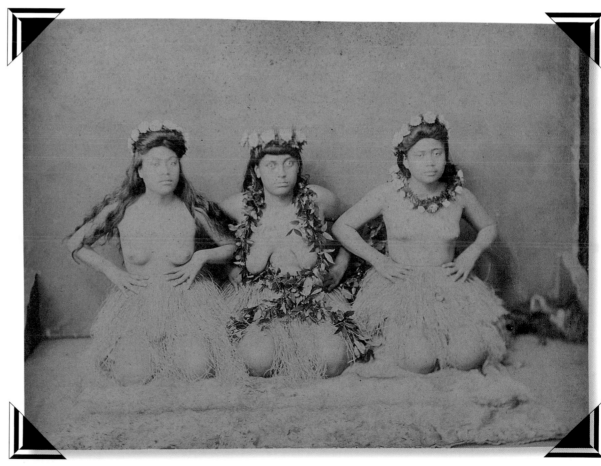

69

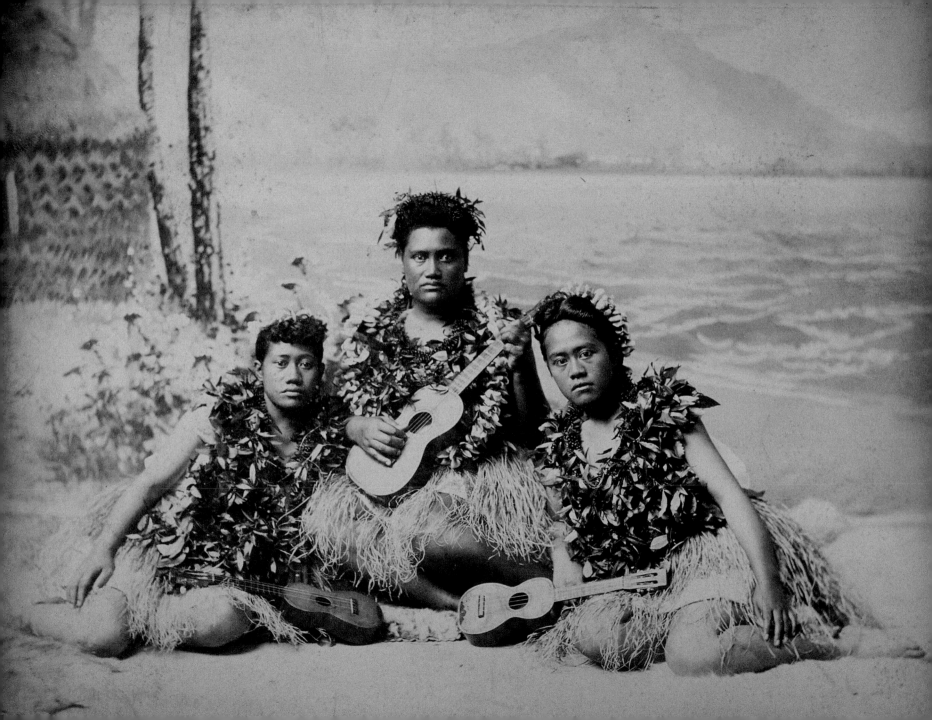

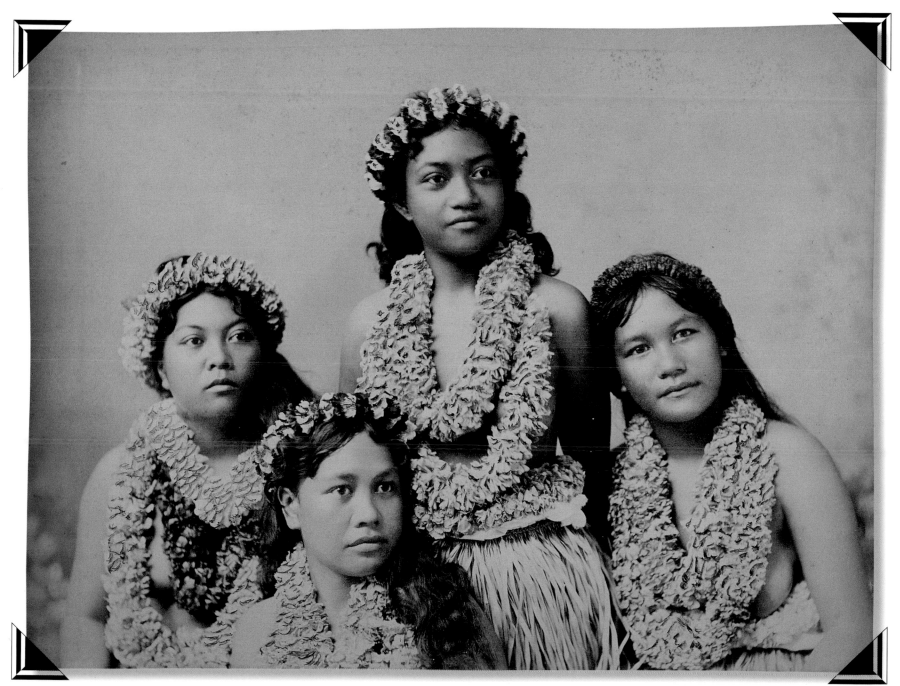

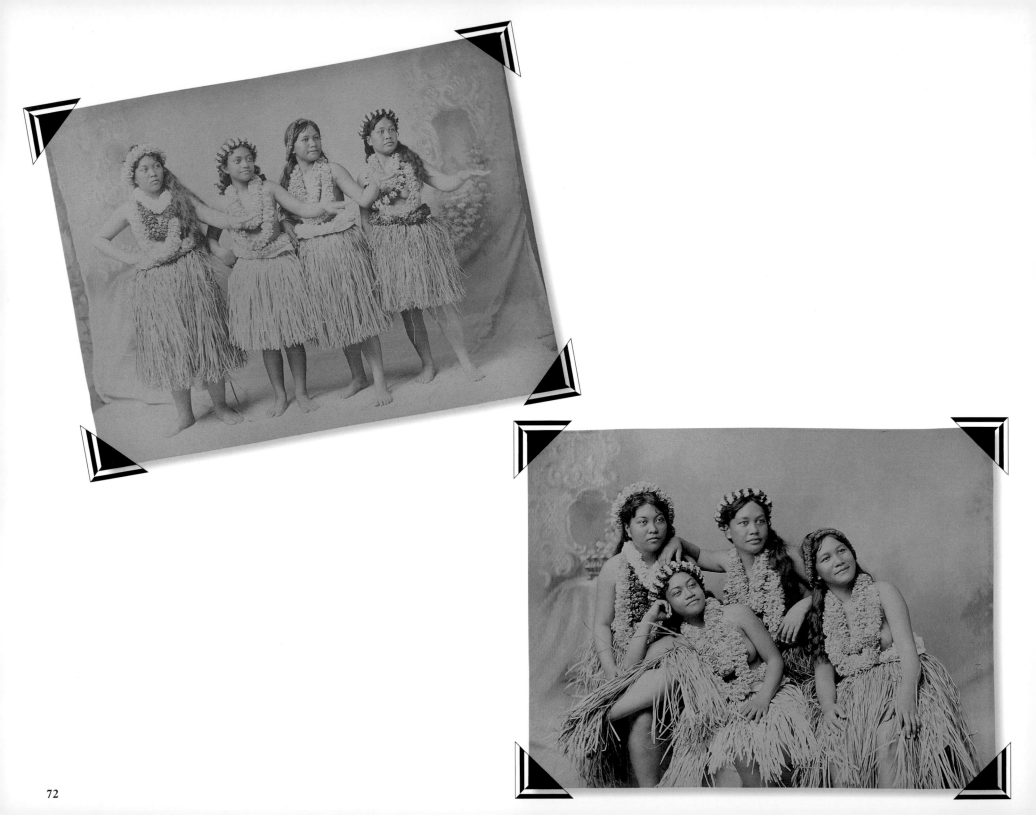

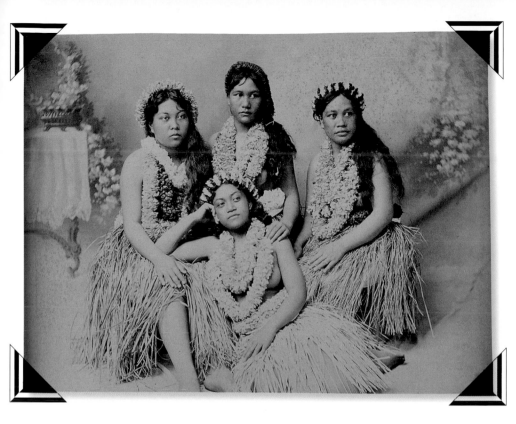

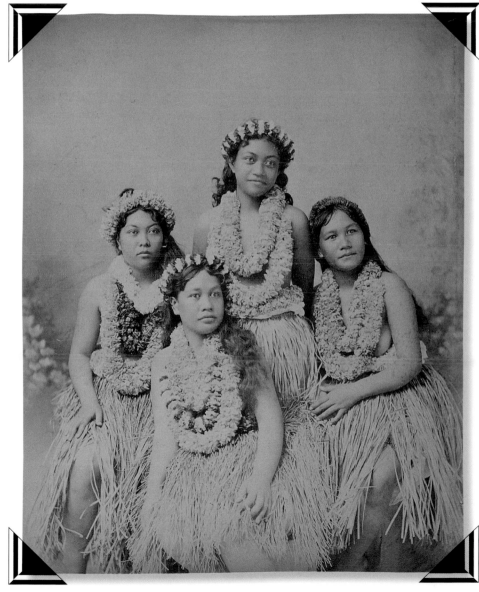

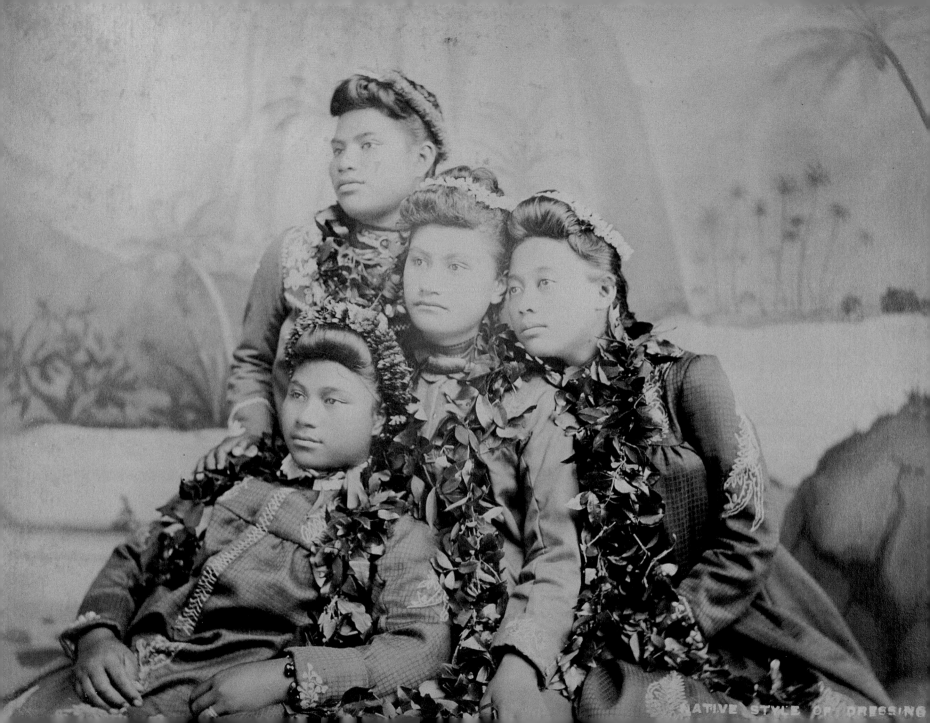

NATIVE STYLE OF DRESSING

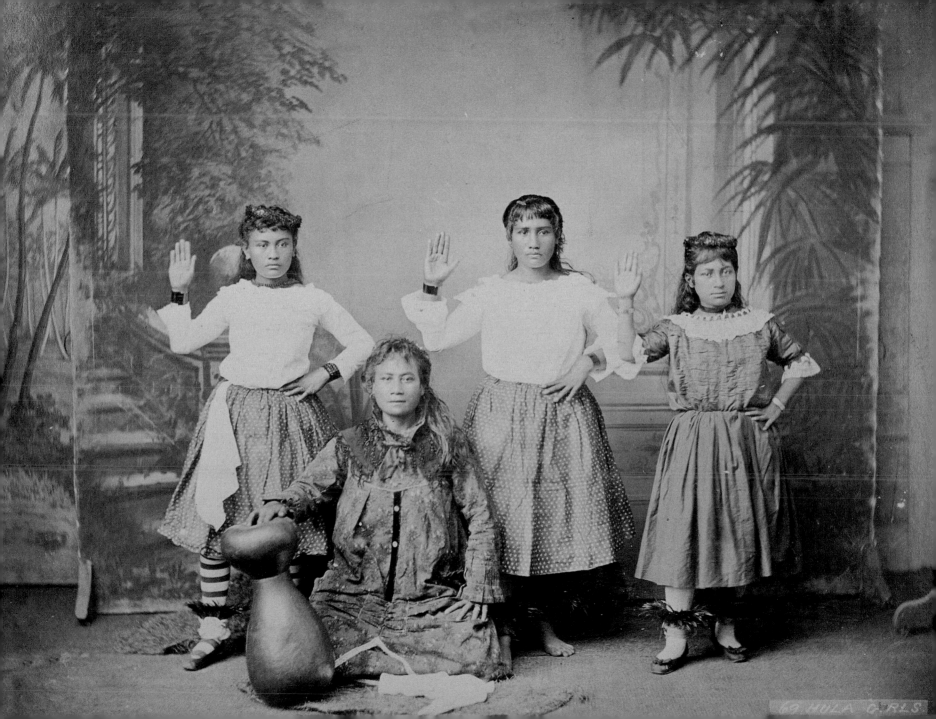

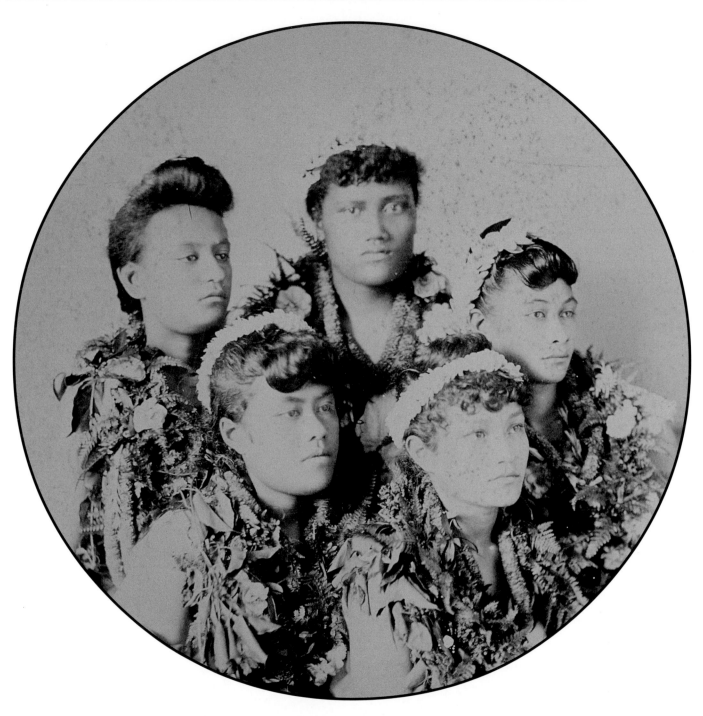

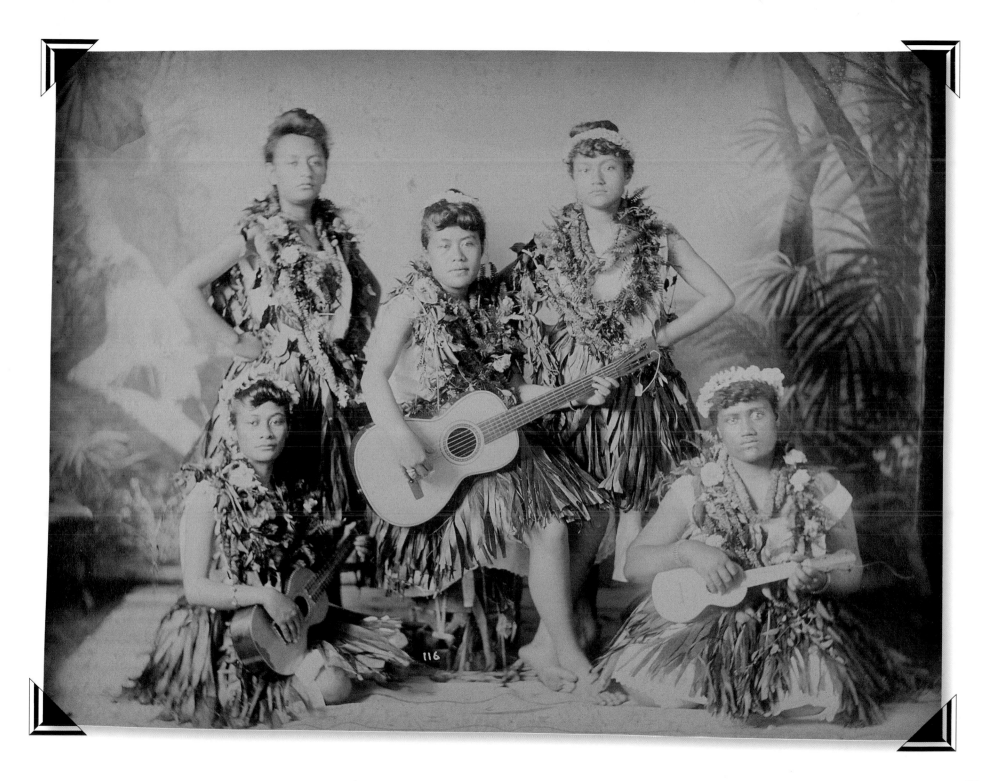

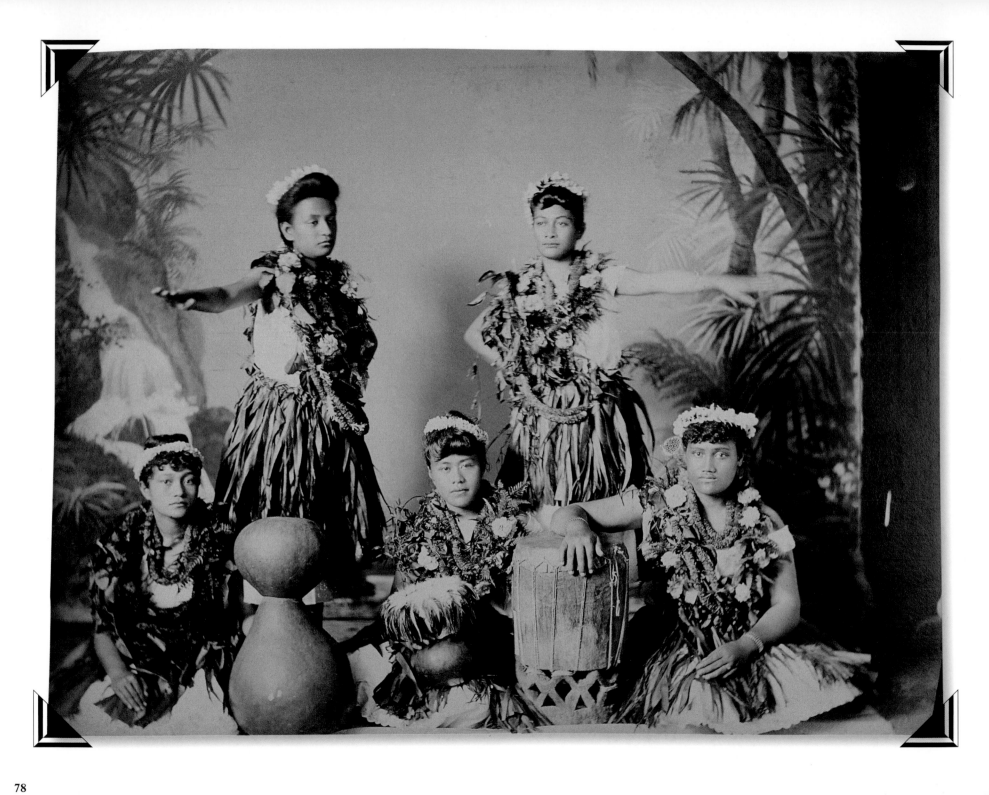

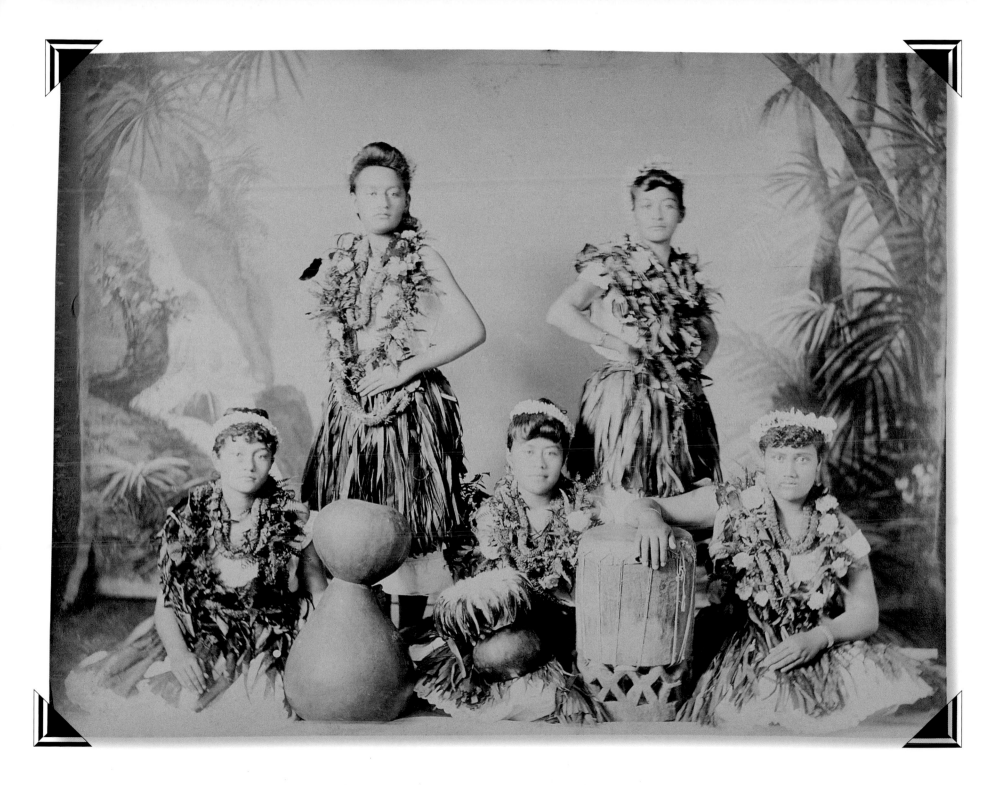

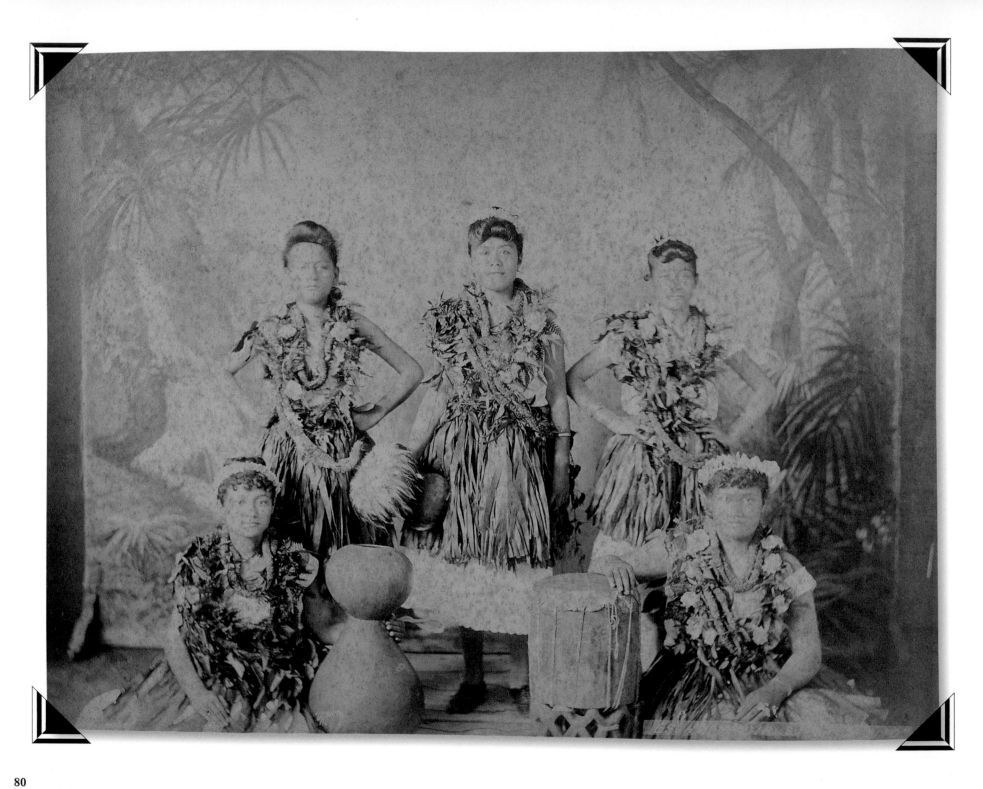

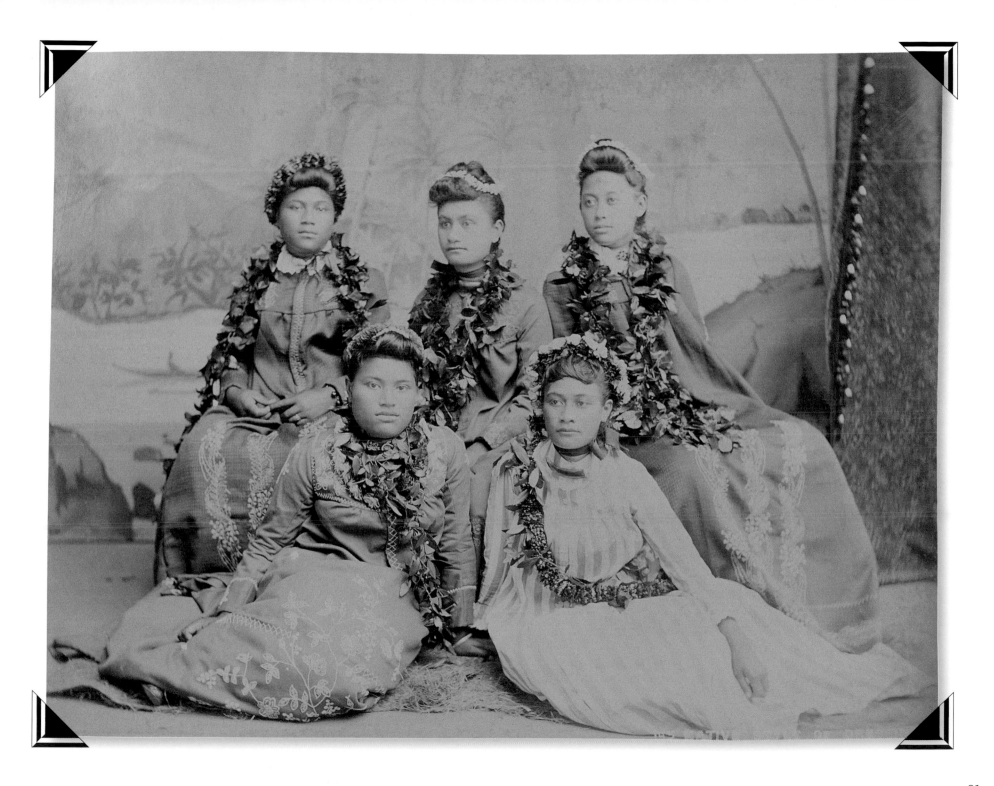

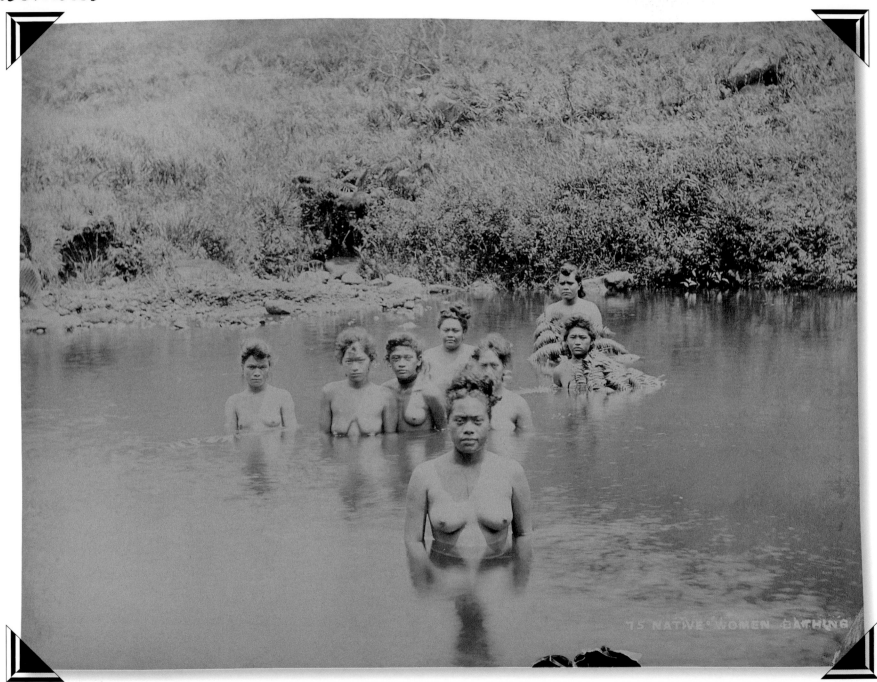

'75 NATIVE WOMEN BATHING

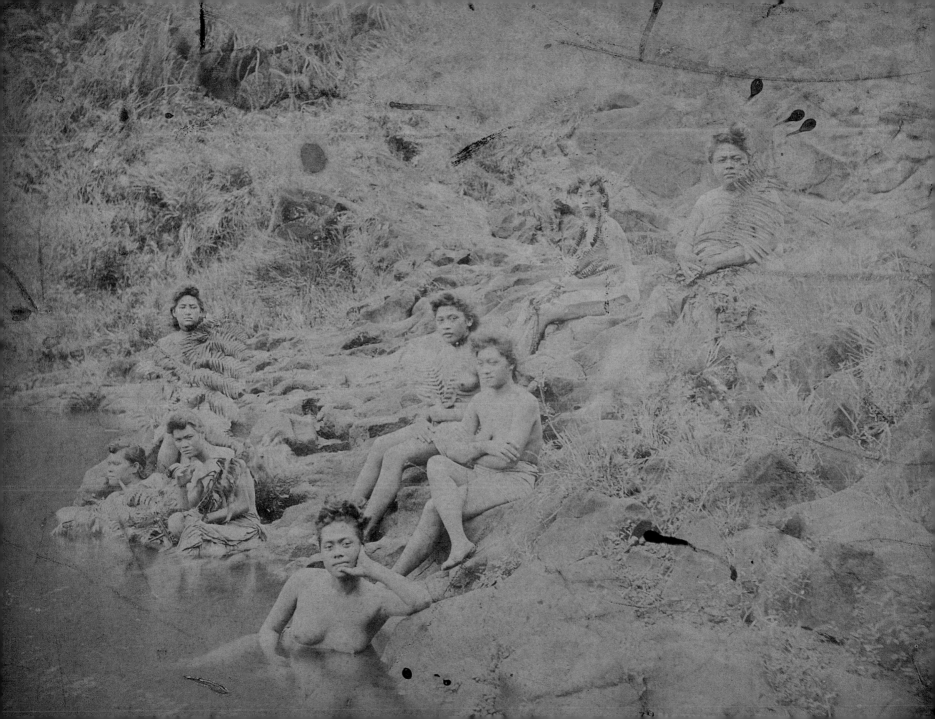

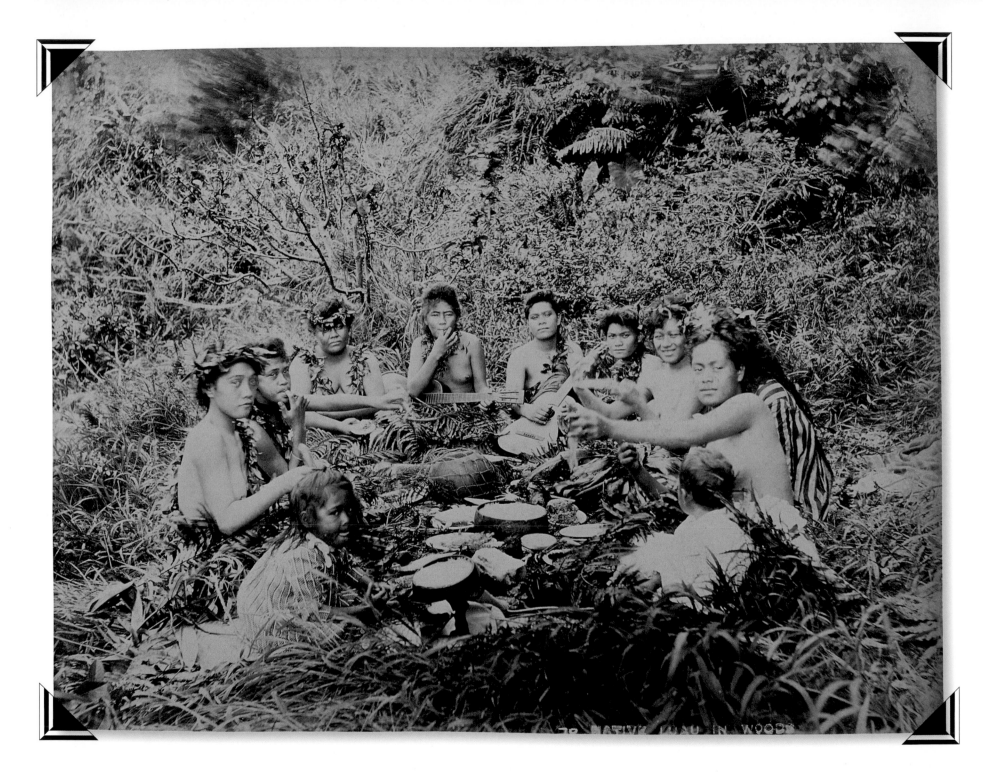

J. J. WILLIAMS
HONOLULU, H. I.

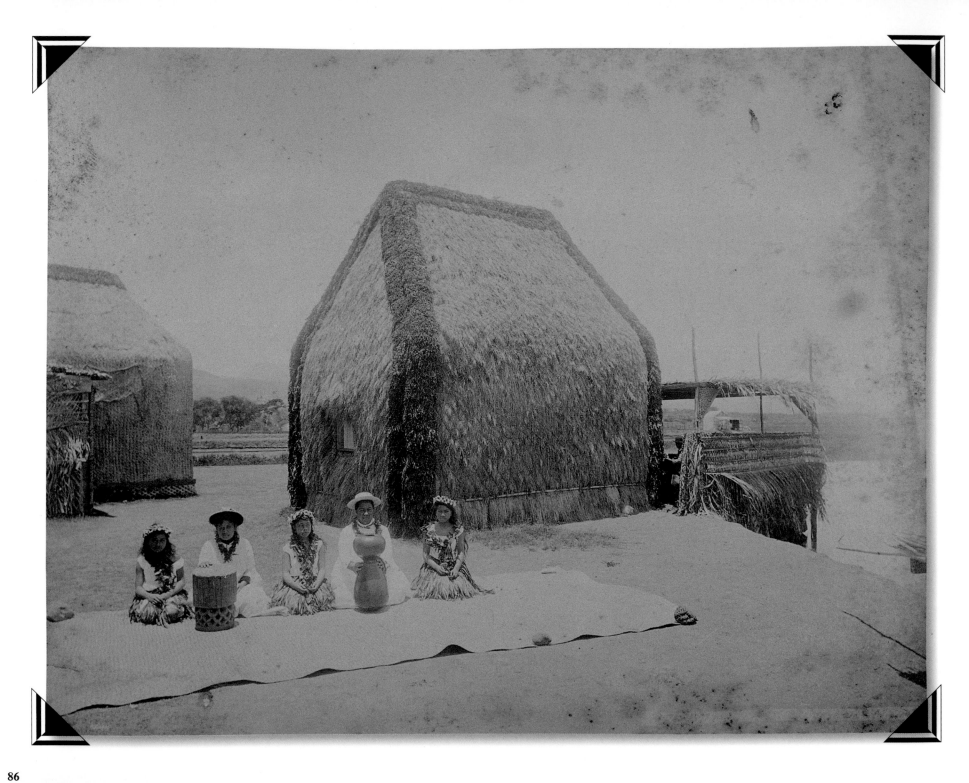

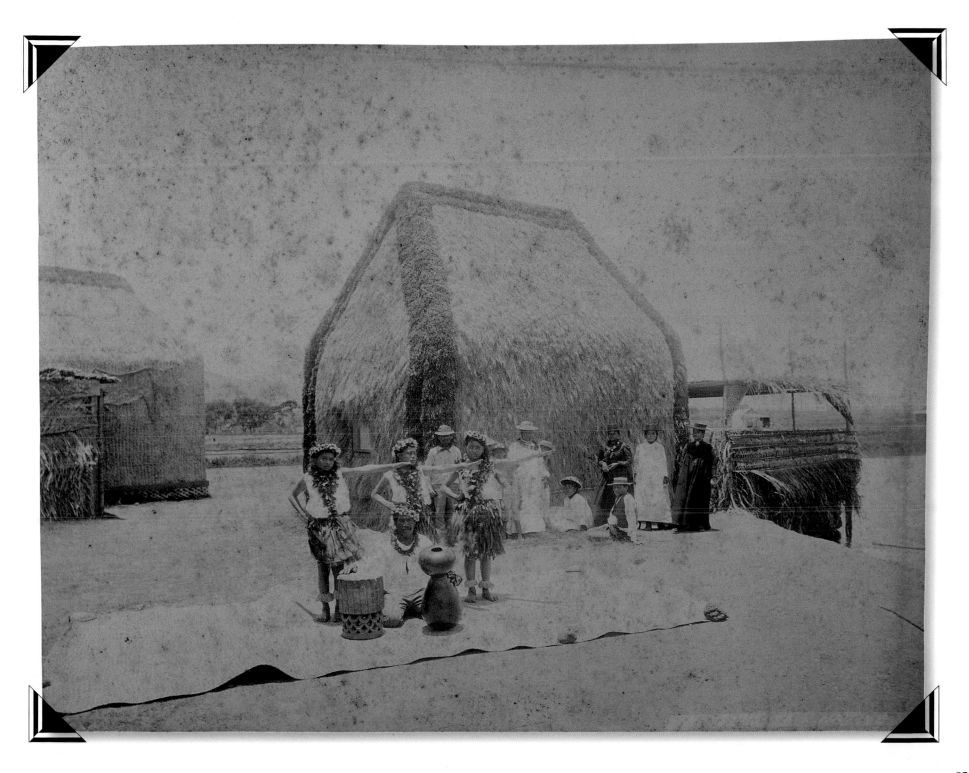

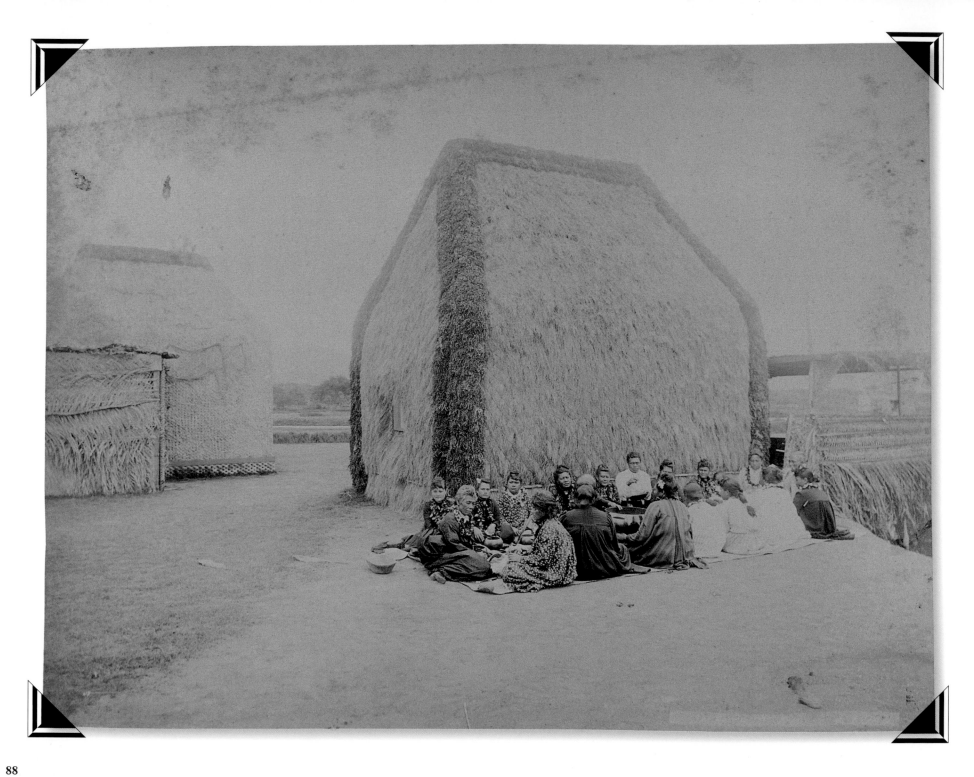

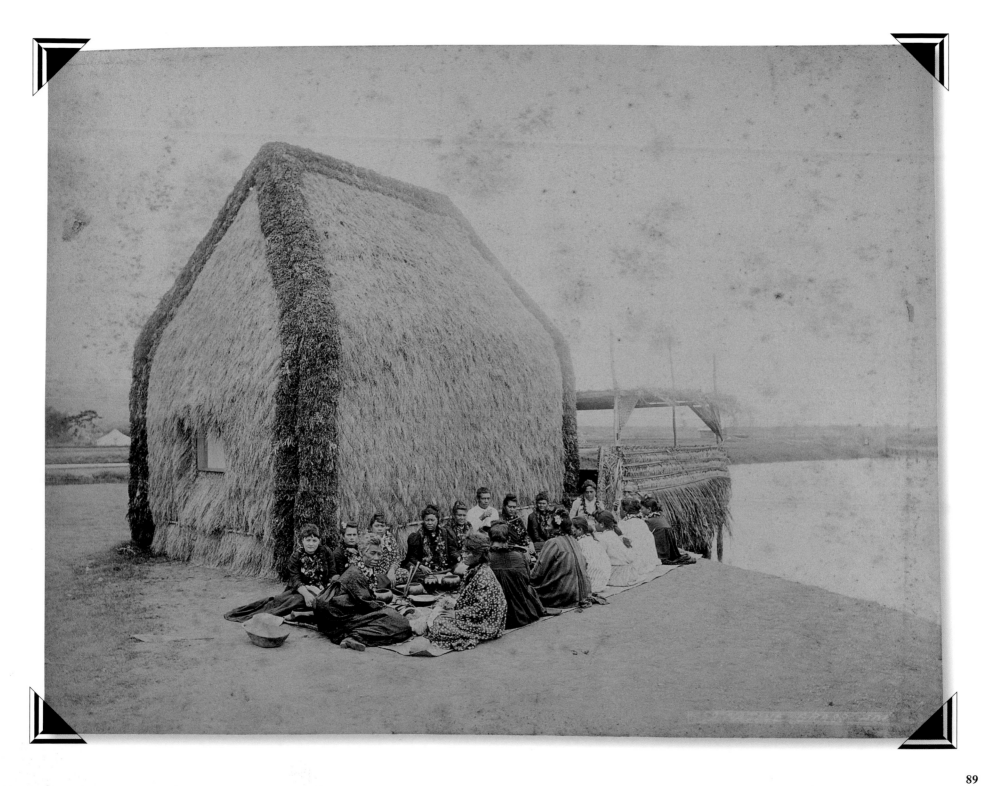

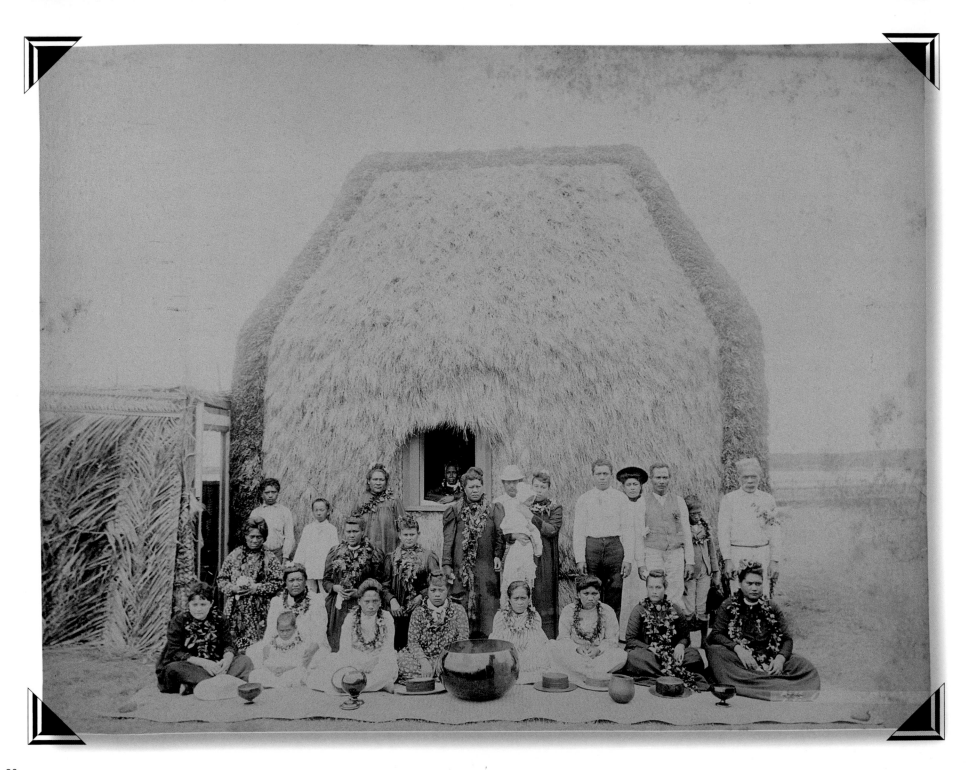

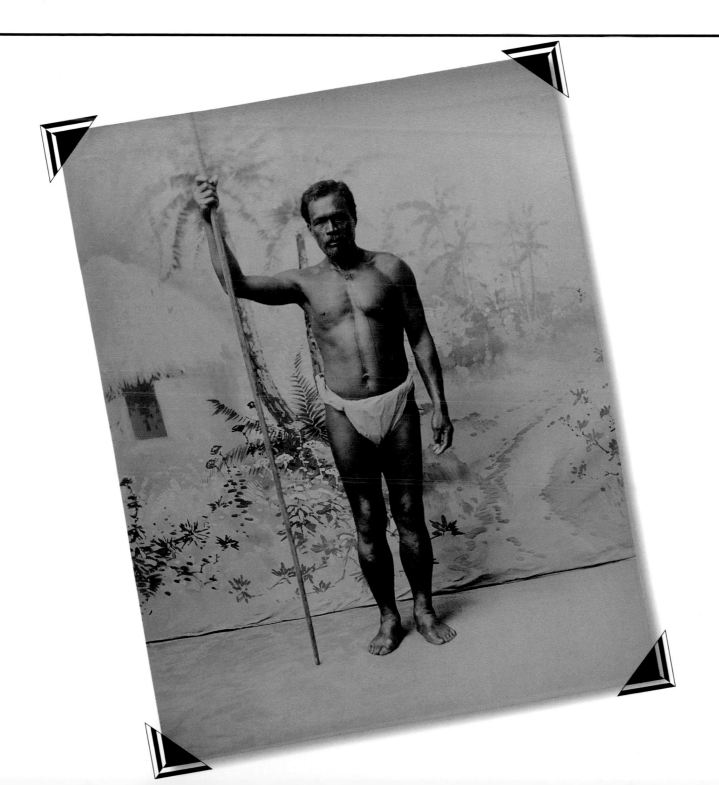

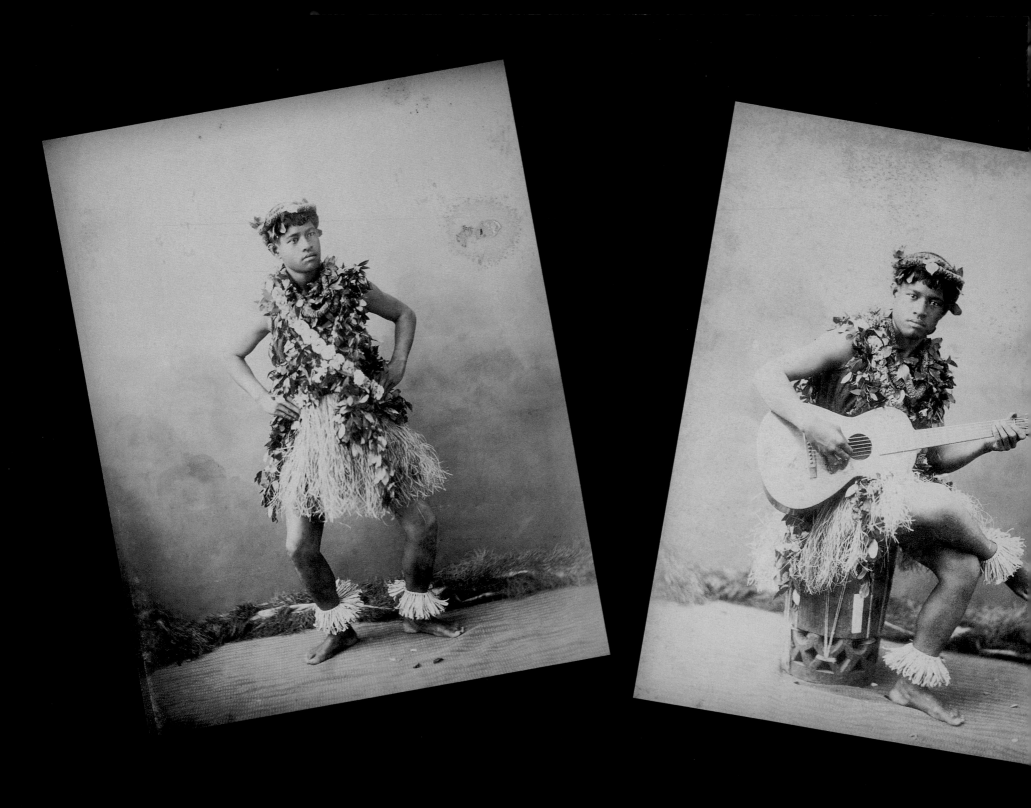

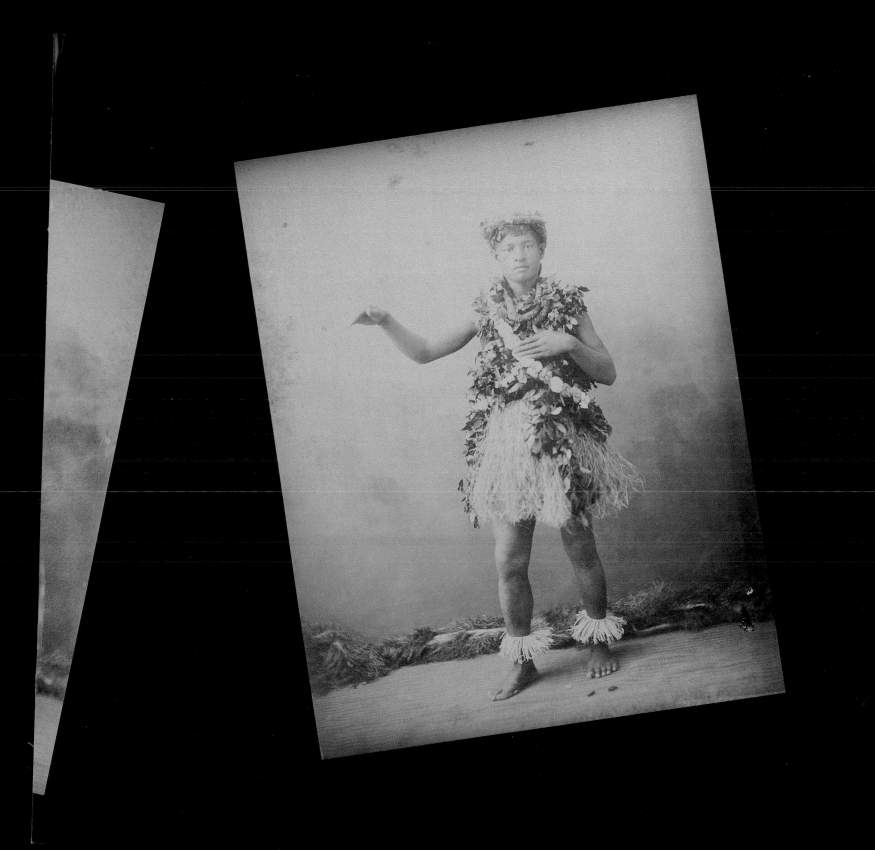

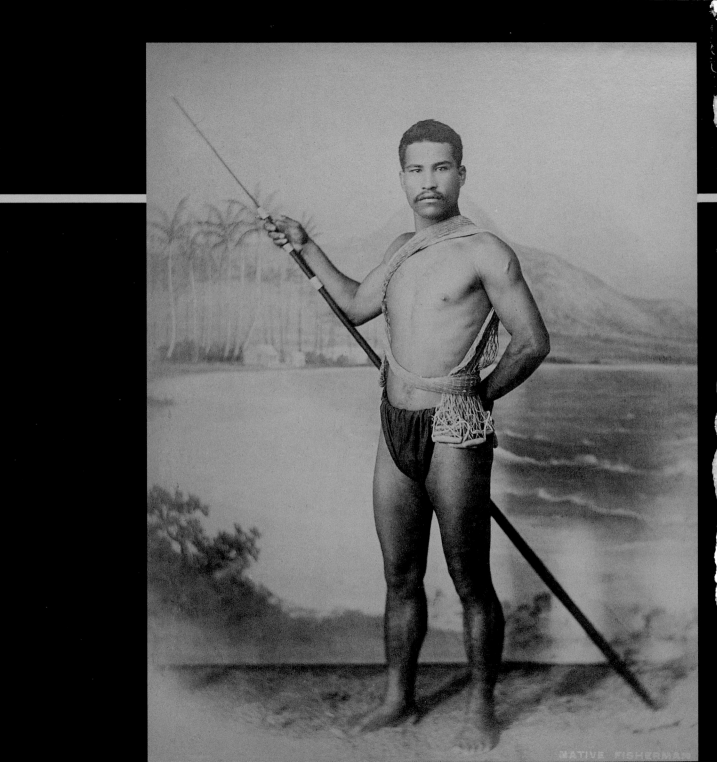

NATIVE FISHERMAN

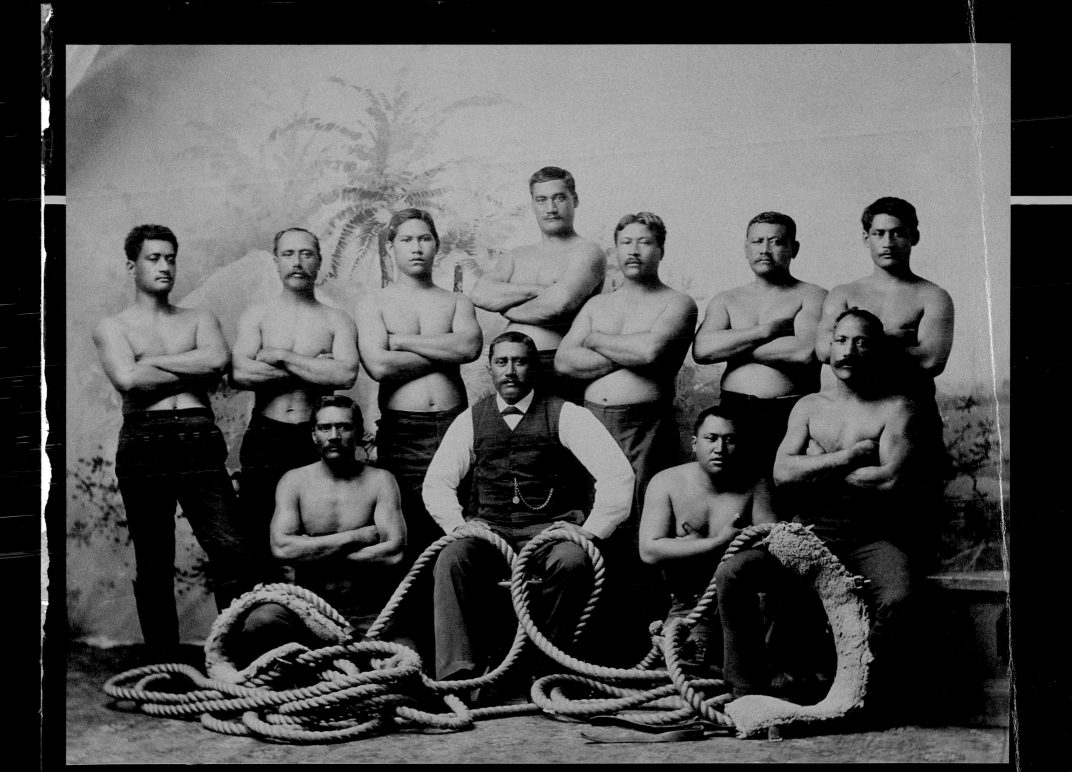

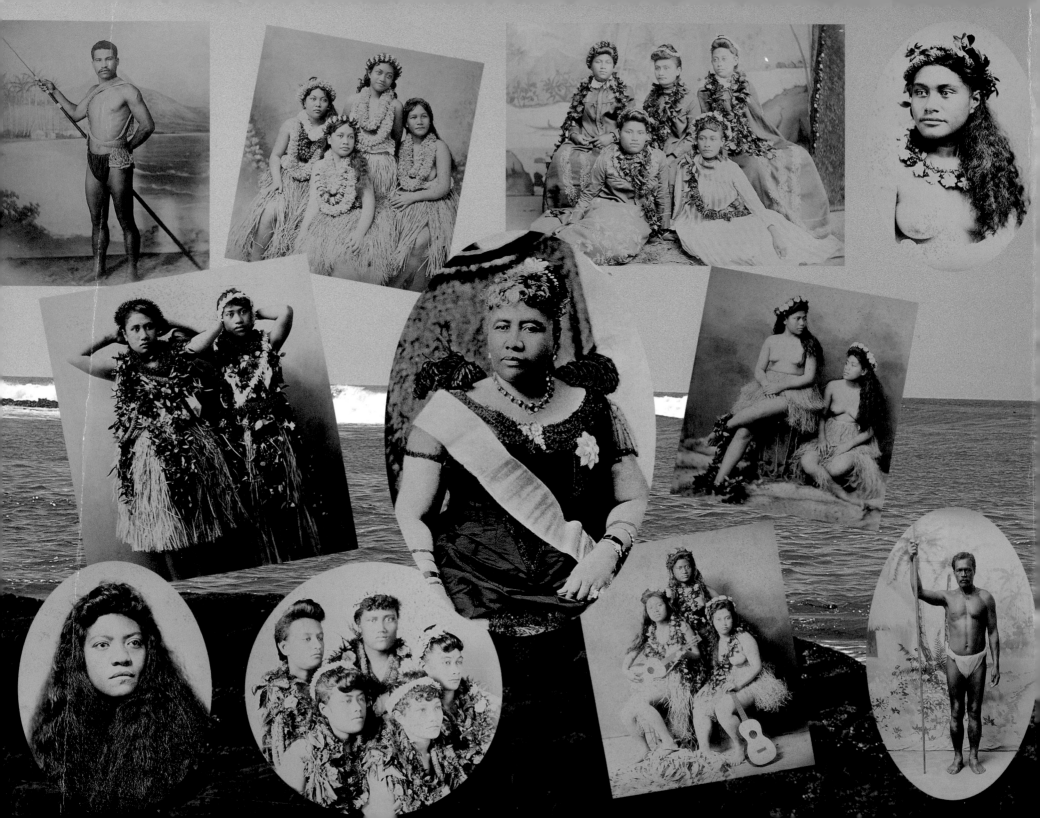